FIRST-GENERATION PHOTOGRAPHER

@ U.S. Space & Rocket Center

STEVEN JACKSON

AuthorHouse™
1663 Liberty Drive
Bloomington, IN 47403
www.authorhouse.com
Phone: 833-262-8899

Because of the dynamic nature of the Internet, any web addresses or links contained in this book may have changed since publication and may no longer be valid. The views expressed in this work are solely those of the author and do not necessarily reflect the views of the publisher, and the publisher hereby disclaims any responsibility for them.

Any people depicted in stock imagery provided by Getty Images are models, and such images are being used for illustrative purposes only.
Certain stock imagery © Getty Images.

This book is printed on acid-free paper.

Interior Image Credit: Steven Jackson

ISBN: 978-1-7283-7877-0 (sc)
ISBN: 978-1-7283-7878-7 (e)

Print information available on the last page.

Published by AuthorHouse 01/25/2023

authorHOUSE®

April 19, 2004, I traveled from New York City to visit Huntsville, Alabama for the first time.

Image Taken by Steven Jackson Photography / March 31, 2019

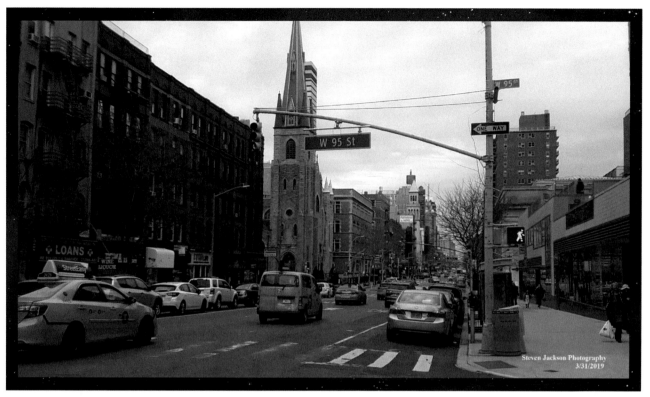

NEW YORK

Why Huntsville you might ask? Well, for one, I have family members who reside here and second, Huntsville is the perfect starting point for me to move forward with my family tree research. Many years, I have been curious about my ancestry so, I decided to dig deep into the life of my great grandfather, Donaldson Little (1887-1977) born in Sumter, Alabama.

Many times, I had driven my car to Huntsville and other times, I'd travel by Greyhound bus.

Image Taken by Steven Jackson Photography

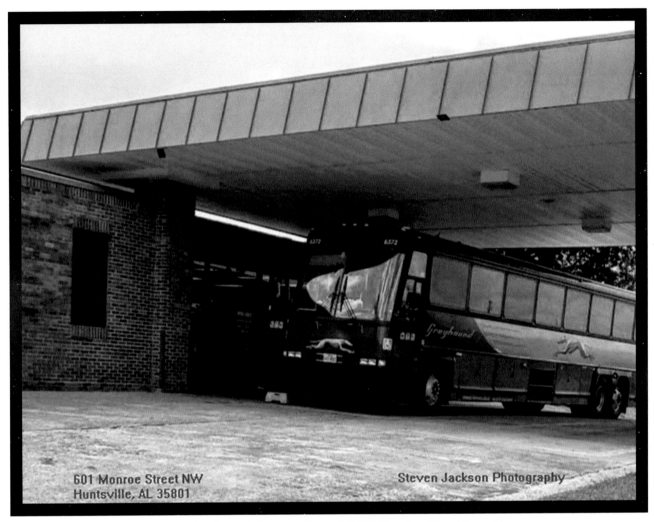

Huntsville Greyhound Station / 601 Monroe Street NW Huntsville, AL 35801

Each trip, I ride on I-565 Highway headed towards the Huntsville bus terminal, I would pass by the Davidson Center building that sit on top of an upgrade hill off exit 15. Each time, I'd ask myself what is the Davidson Center? Yes, it's true that I could've Googled my question, but I didn't do that. Instead, I would continue to focus on my departure at the bus terminal 500 Church Street downtown Huntsville. By the way, my bus was right on schedule.

11 years, I traveled back and forth from New York to Huntsville until March 2019; on that date, I unpacked my suitcase for the last time to become a Huntsville resident. I bring with me many years of experience as a seasoned photographer skilled in a variety of photographic sectors in the colorful world of photography.

During those days when, I didn't have a personal car to get around Huntsville my favorite place to rent vehicles was with Enterprise Car Rentals located at 11803 Memorial Parkway SW, across the street from a Super Walmart store. Side note, I like this Walmart for many reasons; 1.) their fruits and vegetable section seem fresh and ready to be purchased. 2.) The store is well laid out in a relatively easy way to maneuver through the aisles for shopping. 3.) Their prices are reasonable, and the location is ideal. I wanted to share that experience with you while it was fresh on my mind.

Ok, so… after I booked my vehicle online and when, I arrive at the car lot my rental is clean and ready to hit the road. By this time, I'd built up a strong appetite. With that said, my next stop is I-HOP restaurant located at 3001 Memorial Parkway SW, 35801 on Drake Ave. across from Parkway Mall, only 4 miles driving north on highway 231 just 4 miles from Enterprise. How convenient is that!

By the way, when, I go to the Parkway Mall, I must stop by the food court so, I can get the free teriyaki chicken samples at the Teriyaki Japanese restaurant. For me, absolutely delicious.

Guess what!

This teriyaki restaurant will have one of their workers stand out in front of their eatery to give away free sample teriyaki chicken on a toothpick to people who walk by. How cool is that! By the way, I must admit, I walked by twice. Yes, I did; two times!

But I have to say, if you're hungry that tiny sample of chicken is not enough to satisfy your hunger. So yeah, I had purchased an order to go!

RESEARCH

I remember the time when, I was grocery shopping in a local Walmart store when, I overheard two other shoppers talking about the Davidson Center. Immediately they caught my attention to have me eaves-drop even further. Then, I was compelled to ask, what is the Davidson Center?

As we walked down the potato chip aisle, I was there to purchase Lays BBQ potato chips; they explained to me what the Davidson Center was and how it functioned at the U.S. Space & Rocket Center. Mind you, this is the very first time that, I had ever heard of the U.S. Space & Rocket Center. I was blown away from what they had to say. How come, I didn't know?

A short time later, I had finally Googled the U.S. Space & Rocket Center to learn more. Come to find out that the U.S. Space & Rocket Center have one of the largest collections of space rockets and space memorabilia on display than anywhere in the world. How cool is that! Who knew!

That's when, I also discovered that they had just added a new photography department in place at the location. Right away, I had to apply there. While online, I Googled a website called indeed.com (a free employment service for job seekers). A platform created where professionals can find career opportunities in their skill sets regardless of where you live.

APPLICATION PROCESS

Even though, I don't believe in luck... I'm going to say it anyway; Lucky me; the U.S. Space & Rocket Center had posted a job opening for staff photographers. As you know, I filled out the required application and attached my resume. FYI... so you know, my resume is very impressive. Ok, so... two weeks later, I received an email from the Office of Human Resources.

U.S. SPACE & ROCKET CENTER
Image Taken by Steven Jackson Photography / May 15, 2019

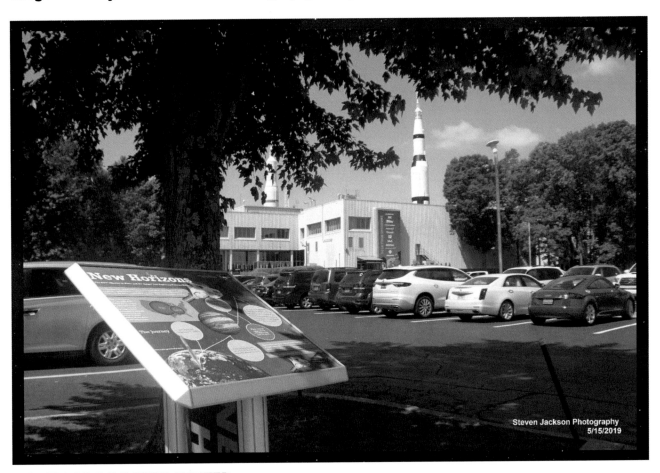

U.S. SPACE & ROCKET CENTER

STATUS OF APPLICATION AT THE U.S. SPACE & ROCKET CENTER

Camp Photographer U.S. Space & Rocket Center Foundation -5/7/2019 (Yahoo Email)

Hello Jackson,

Thank you for applying to the U.S. Space & Rocket Center. At this time, your application has been reviewed and sent to the hiring manager for the Camp Photographer position. After the manager review your application, you will receive an email from us with an update on the status.

Sincerely,

Office of Human Resources
The U.S. Space & Rocket Center

The U.S. Space & Rocket Center does not discriminate on the basis of race, color, national origin, gender, religion, age, veteran status, or any ADA defined disability in employment. An equal opportunity employer & ADA compliant.

EOE / MINORITIES / FEMALES / VET / DISABLED

U.S. SPACE & ROCKET CENTER
Image Taken by Steven Jackson Photography / May 15, 2019

INTERVIEW: STAFF PHOTOGRAPHER
MAY 15, 2019

Mr. Kerry Brooks is the supervisor in charge of the new photography department that was recently established here at the U.S. Space & Rocket Center. My interview appointment was scheduled for 1:00pm; I arrived at 12:45p. Mr. Brooks greeted me at the Bush Room entrance.

He escorted me to his office, invited me to take a seat and then introduced himself. Kerry gave me a brief talk about his background and what the photography job entails. I was asked a series of questions about my photography experience and what photography gear, I normally use. The interview lasted 50 minutes ending with me accepting the staff photography position. Kerry is looking to fulfill his staff roster by hiring five more photographers by June 1.

From that moment, I had become a proud employee of the U.S. Space & Rocket Center. How cool is that!

The second part of my interview was the background check and drug test. This final stage of the hiring process was mandatory and of course, I passed with flying colors.

A week later, I attended an orientation meeting for all new hires associated with various departments throughout the facility. We met in the National Geographic Theater in the Davidson Center. What a joy that was for me. I finally get to physically make my way into the Davidson Center to see what artifacts were displayed in such a historical building. How cool is that!

We will address the Davidson Center later.

DAY 1

Ok, so; my first day on the job was super exciting and super challenging at the same time.

Starting a new job can be a challenge at times especially when all the information about your job duties given to you days before, evaporates from your memory. I think, I had experienced a temporary brain-freeze more than once. However, when you're a seasoned photographer, you tend to recover very quickly. I adapt and I conquered the SOP (standard operating procedures) in photographing everyone who had to be photographed, kids and adults alike. No joke! I love every minute of this job. When you come here for your own experience, you will feel the energy that I and other family and friends felt. This is where you should visit on your next vacation and when you get here ask to be photographed by me. Bring this book so, I can sign it!

Now allow me to paint a clear picture of what my first day on the job looks like.

When, I arrive to work the first thing, I have to do is clock-in. I will use the time and attendance system to clock-in and I will use this same system to clock-out at the end of my work shift. This time clock machine is mounted on the wall in a designated area used by all the employees of the U.S. Space & Rocket Center.

When, I proudly walk through the door of the photography office, I greet whoever is present then, I gather the necessary equipment needed to successfully do my job.

The camera that I use is the Sony a7iii full frame mirrorless camera w/ attached battery pack, compatible batteries, lens, sd memory card and camera shoulder strap. Not hard, right!

Next, my supervisor and I will review my work schedule for the day to strategize my assignments. Since this is my first day on the job, I will work alongside another photographer who will attempt to train me at the various activities listed on my schedule. This photographer was hired a few weeks before me. I'm now pumped up ready to capture memorable moments.

I start my first day on the job at the most challenging area on campus, "The MCC Floor". This area is part of the U.S. Space & Rocket Center, Space Camp program. The kids and adults who participate in the various programs here are referred to as "space camp trainees"; and The MCC Floor is a multi-functional, space training facility.

THE MCC FLOOR
Image Taken by Steven Jackson Photography / Feb. 15, 2020

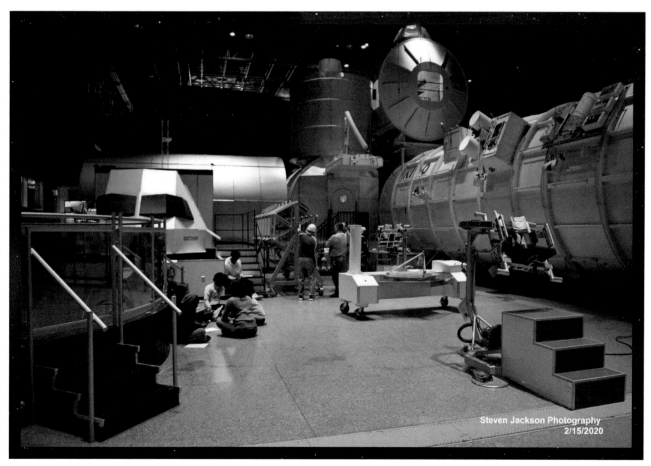

The MCC Floor is where crew instructors lecture space camp trainees. Multiple lectures are conducted at the same time at different sections on The MCC Floor. Every person who trained on The MCC Floor loves this station. The MCC Floor is out of this world! How cool is that!

Ok, let's get into it! When space campers arrive at this campus, they are assigned a crew trainer.

LET'S TAKE A MOMENT TO DEFINE WHAT A CREW TRAINER IS

A crew trainer is a person (male or female) whose job is to over-see a team / crew of sixteen individual kids or adult campers. The crew trainer gives lectures in the history of various space programs, gives insight in aviation, space travels, space simulations, provide knowledge related to robotics and much, much more! Simply put, a crew trainer is the one who will educate and supervise trainees from sun rise to sunset. Trainees will be trained as if they are real engineers, scientists, and astronauts. Sounds like a great deal of fun! How cool is that!

THE MCC FLOOR
Image Taken by Steven Jackson Photography

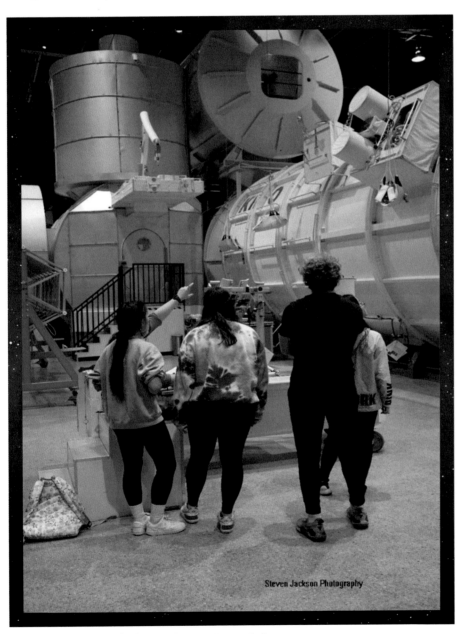

The MCC Floor / Micro-Group in training.

The crew trainer will escort his or her team to The MCC Floor where the team will be broken down into smaller micro-groups for easy management and to allow each micro-group to learn a specific task and cross train at different stations related to their specific space missions. Once the crew trainer has escorted his team to the training station that crew trainer is replaced by a crew instructor who will go over the safety procedures before he begins to teach. The responsibility of the crew instructor is to educate the trainees on how to successfully perform their space mission.

Let's give this first team a name for identification purposes. Let's call them, "Team Venus".

Image Taken by Steven Jackson Photography

TEAM VENUS

Example: Team Venus is broken down into four micro-groups of trainees who will be individually assigned a space position. Each micro-group has four trainees in the group.

THE MCC FLOOR
Image Taken by Steven Jackson Photography

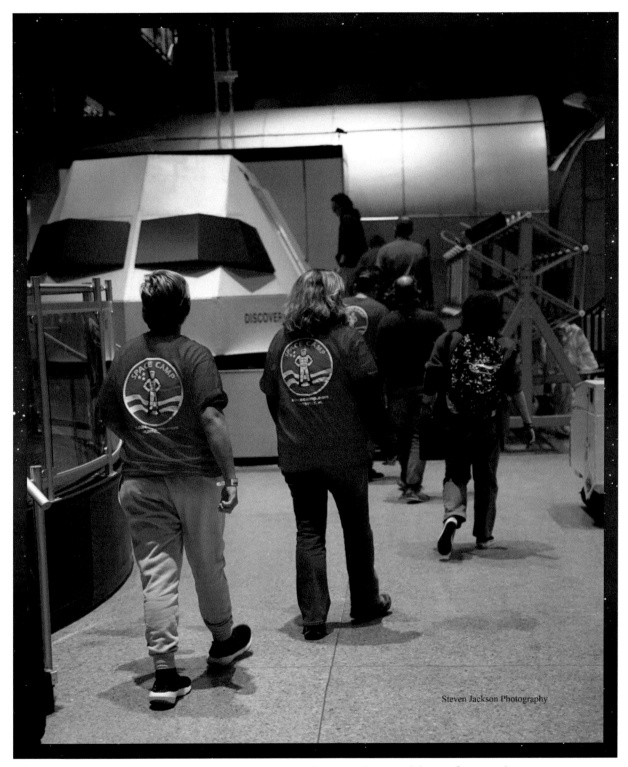

Steven Jackson Photography

The MCC Floor / These Space Campers are about to have a blast of a good time.

THE MCC FLOOR

MICRO-GROUPS

Micro-Group A: Trainee number one is assigned as the pilot (right), trainee number two is assigned as the commander (left), trainee number three is assigned as specialist #1 and trainee number four is assigned as specialist #2; all four trainees are seated in the flight deck.

Image Taken by Steven Jackson Photography

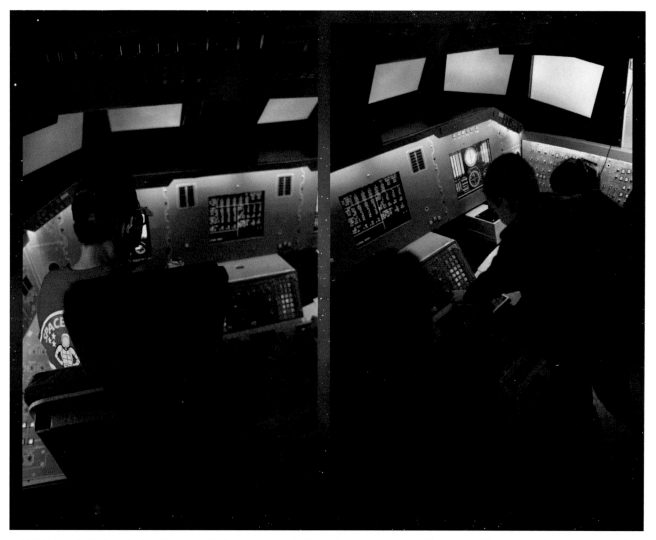

MICRO-GROUP A - Specialist #1, Specialist #2 are seated behind Pilot and Commander

Team members in Micro-Group A are placed in the space flight deck from which they will launch into space, conduct EVA and eventually land on the moon. Now tell me, how cool is that!

EXTRAVEHICULAR ACTIVITY (EVA)… IS ANY ACTIVITY DONE BY AN ASTRONAUT IN OUTER SPACE OUTSIDE A SPACECRAFT WHILE WEARING A SPACE SUIT

THE MCC FLOOR
Image Taken by Steven Jackson Photography / Dec. 28, 2019

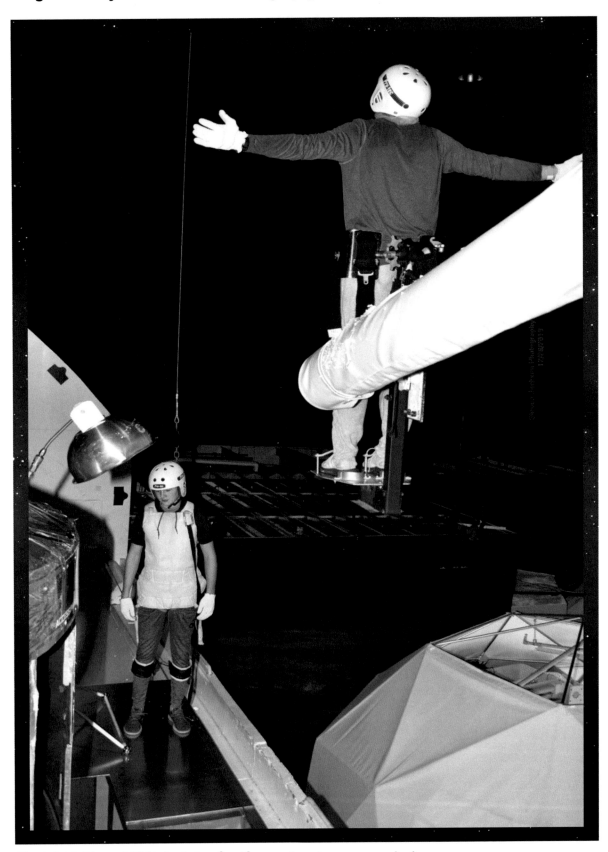

The MCC Floor / EVA training for the next outer space mission

THE MCC FLOOR
Image Taken by Steven Jackson Photography / Feb. 13, 2020

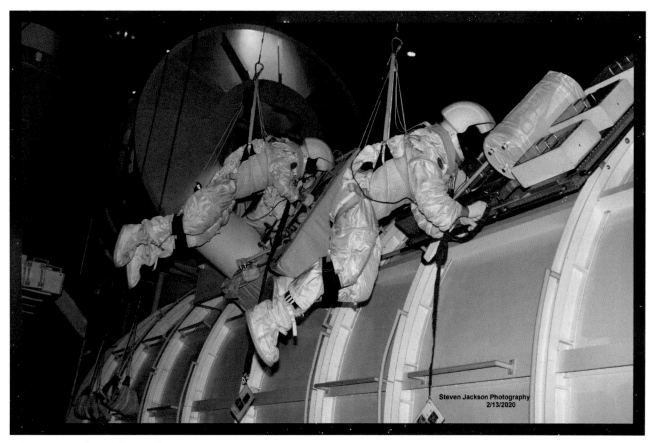

The MCC Floor / Two-hour EVA in progress

Image Taken by Steven Jackson Photography / Feb. 13, 2020

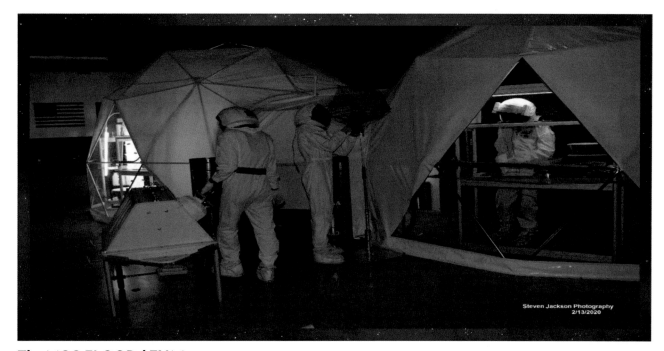

The MCC FLOOR / EVA in progress

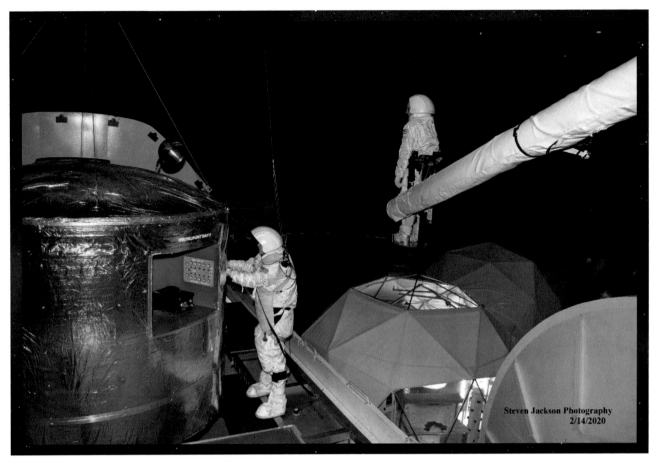

The MCC Floor / EVA space missions are conducted many times daily

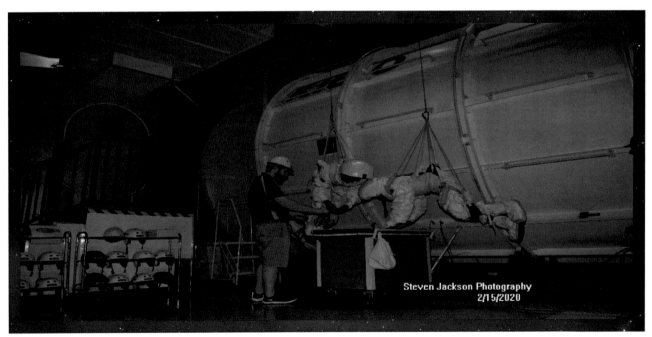

The MCC Floor / EVA in progress with two 12-year-old trainees during their space mission

THE MCC FLOOR
Image Taken by Steven Jackson Photography / Feb. 15, 2020

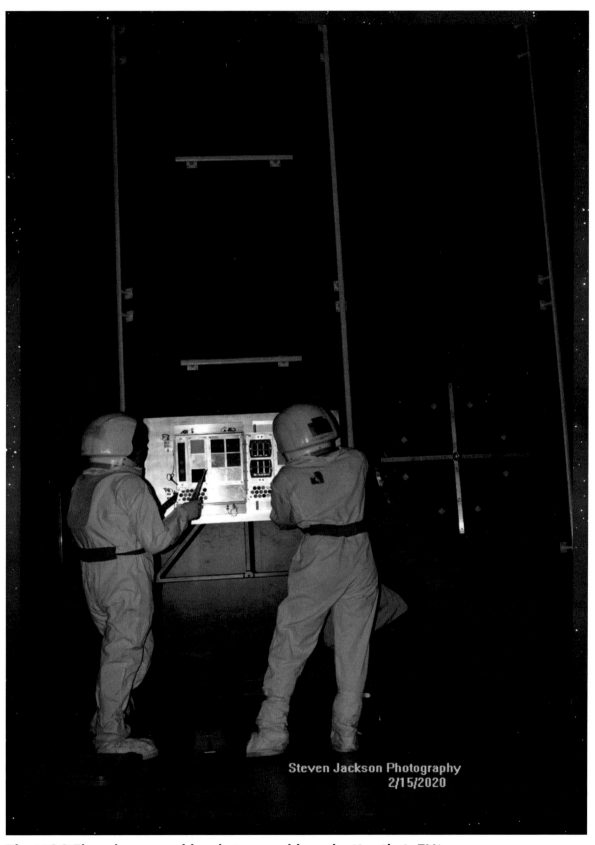

Steven Jackson Photography
2/15/2020

The MCC Floor / 17-year-old and 18-year-old conducting their EVA

MICRO-GROUP B – All four team members are assigned positions in the control room where they sit in front of multiple computer monitors so they can observe their teammates in Micro-group A, C & D and also issue them all flight instructions. Trainees in the control room are responsible for the over-all safety of their team members, the success of this space mission to the moon and back to Earth. This program is a huge space mission. What a challenge!

CONTROL ROOM
Image Taken by Steven Jackson Photography / June 22, 2019

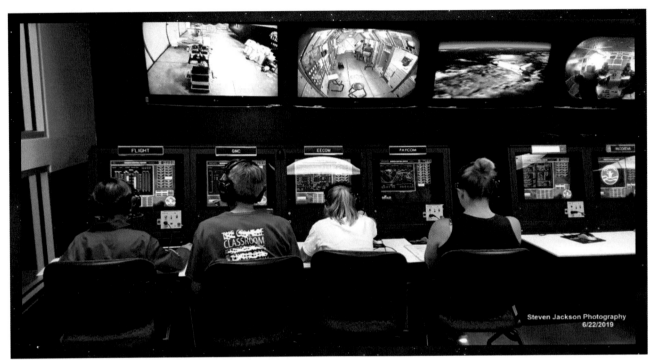

Image Taken by Steven Jackson Photography

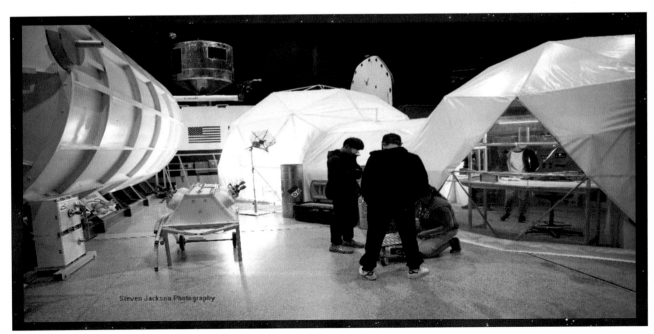

The MCC Floor – Trainees prepare for their space mission

THE MCC FLOOR
Image Taken by Steven Jackson Photography

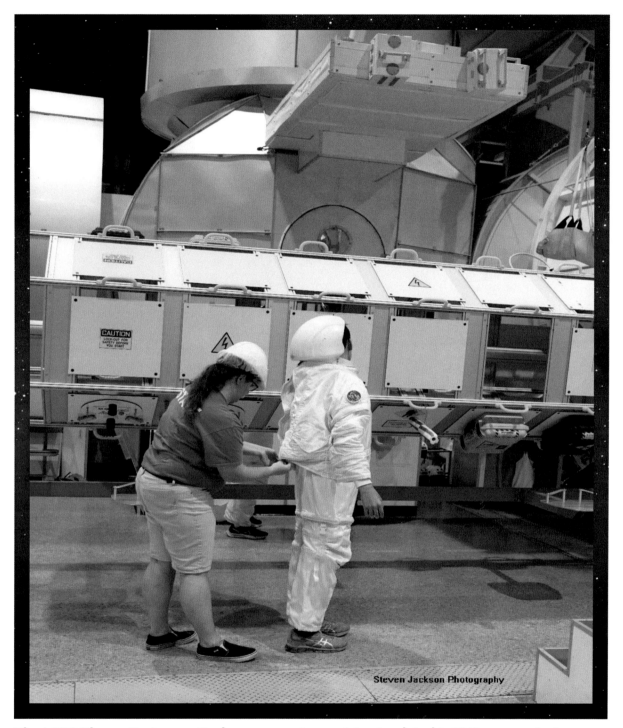

Steven Jackson Photography

The MCC Floor - Trainee suited up as an astronaut to simulate his EVA space mission

EXTRAVEHICULAR ACTIVITY (EVA) is any activity done by an astronaut in outer space outside a spacecraft while wearing a space suit. His self-confidence is extremely high right now.

THE MCC FLOOR
Image Taken by Steven Jackson Photography

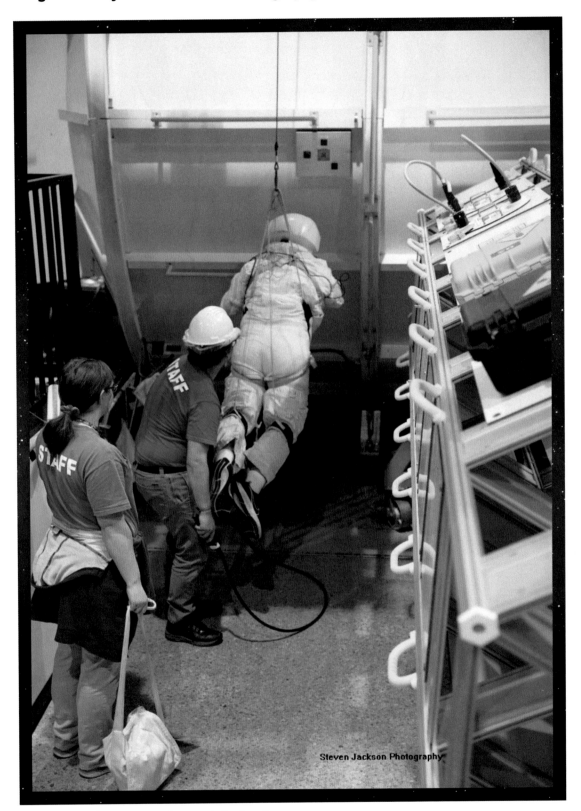

The MCC Floor – EVA Space Mission in progress

THE MCC FLOOR
Image Taken by Steven Jackson Photography

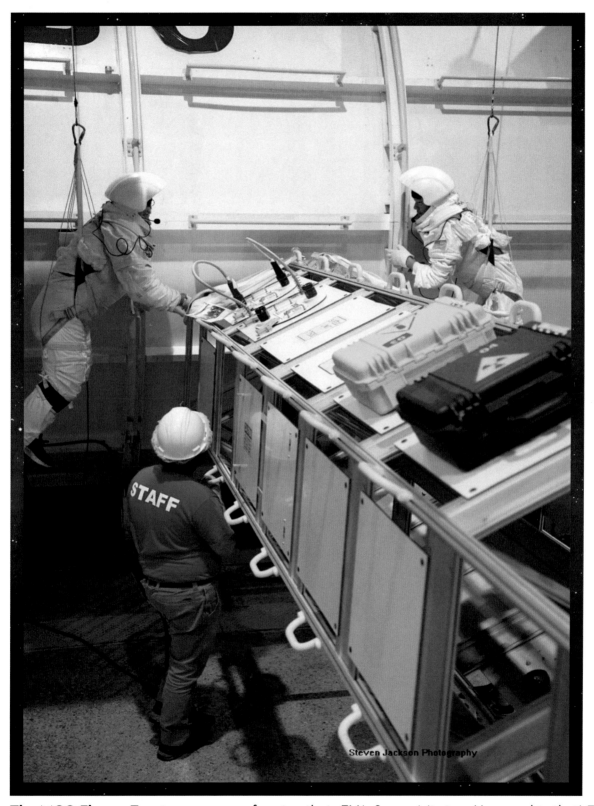

Steven Jackson Photography

The MCC Floor – Two teenagers performing their EVA Space Mission. How cool is that! They will remember this experience forever and ever. This photo will make sure of that!

THE MCC FLOOR
Image Taken by Steven Jackson Photography

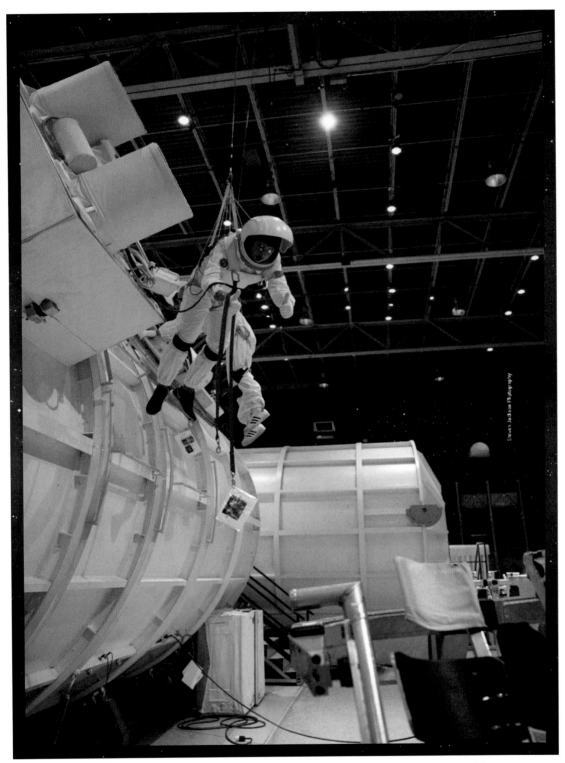

The MCC Floor is a massive area where there are multiple sections used by crew teams to dress-up in space suits and experience the shuttle simulators. The various space modules are built to be used for space simulation training and space missions. It's amazing! This EVA activity is enjoyed by so many people from around the world and I am here to capture the experience. How cool is that!

THE MCC FLOOR
Image Taken by Steven Jackson Photography

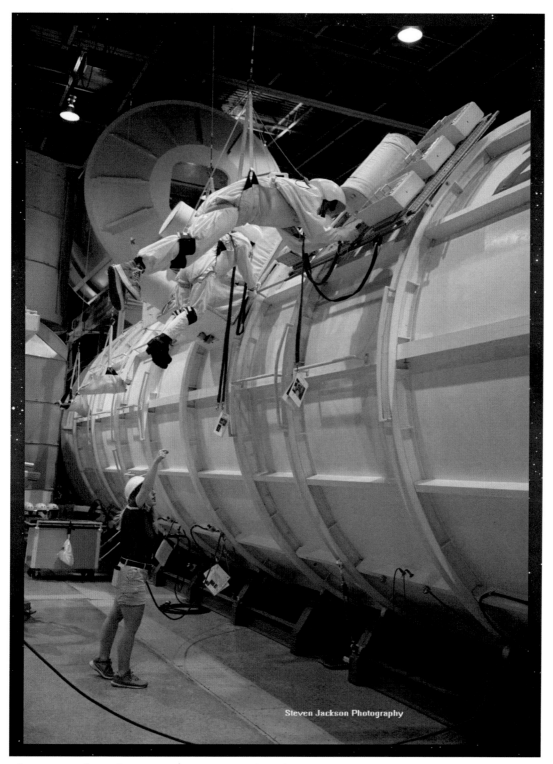

The MCC Floor / EVA in progress with only 45 minutes remaining in the space mission.

THE MCC FLOOR
Image Taken by Steven Jackson Photography

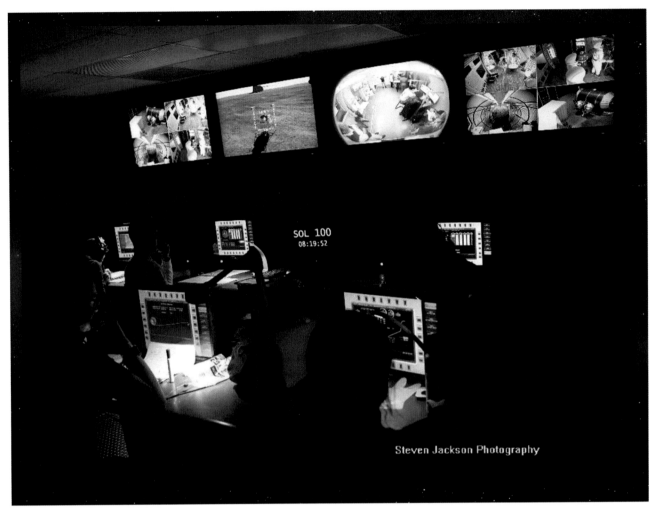

Micro-Group B in the mission control room responsible for being the eyes and ears for the astronauts in flight to the moon and back to Earth. The mission controllers are the ones who work very closely with the astronauts. They are familiar with the spacecraft systems, control systems, fight dynamics and the life support readings aboard the spacecraft.

THE MCC FLOOR
Image Taken by Steven Jackson Photography

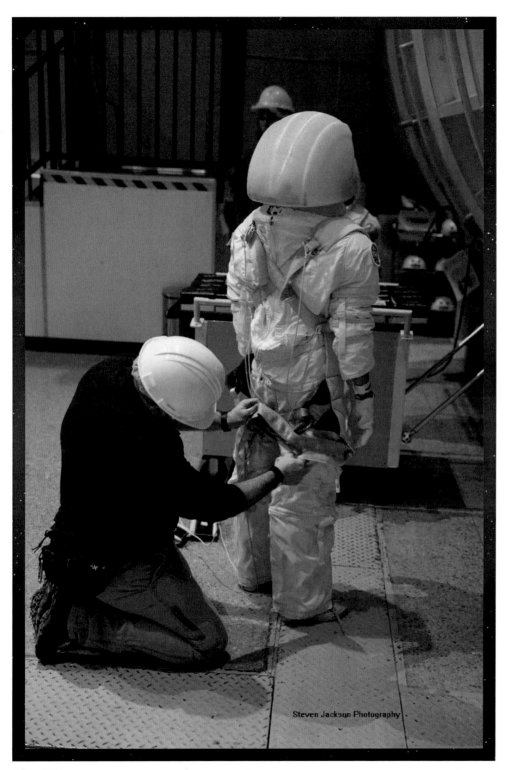

The EVA spacesuits are the most important component to ensuring astronaut safety during spacewalk. Spacesuits are designed to protect astronauts from the deadly elements in space.

THE MCC FLOOR
Image Taken by Steven Jackson Photography

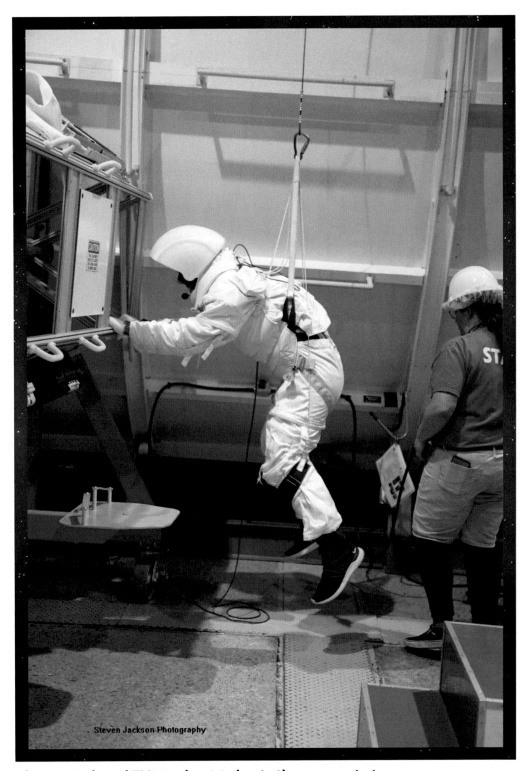

Steven Jackson Photography

The MCC Floor / EVA is about to begin the space mission

THE MCC FLOOR
Image Taken by Steven Jackson Photography

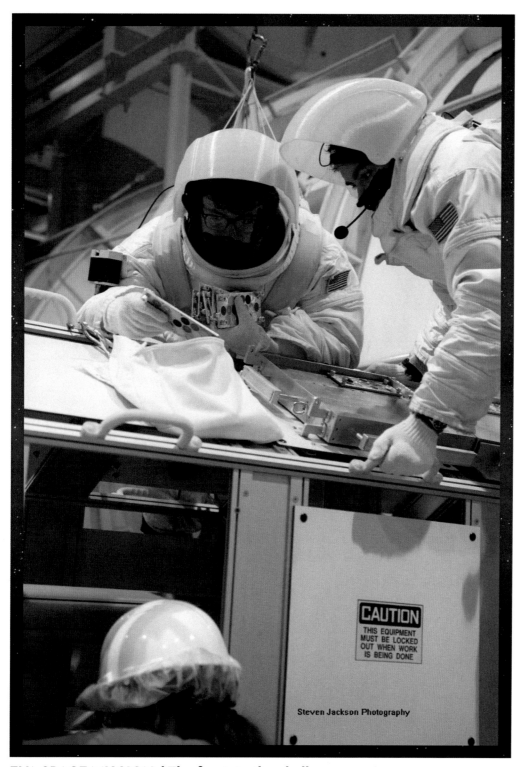

CAUTION
THIS EQUIPMENT
MUST BE LOCKED
OUT WHEN WORK
IS BEING DONE

Steven Jackson Photography

EVA SPACE MISSION / The fun is in the challenge.

DAY 2

U.S. SPACE & ROCKET CENTER AMONG "TIMES MAGAZINE" COOLEST PLACES IN THE WORLD

A few days ago, I had come across an old publication by Times Magazine.

Image: Courtesy: WHNT (WTVY NEWS 4) by WAFF Published Dec 6, 2019 at 4:12AM CST

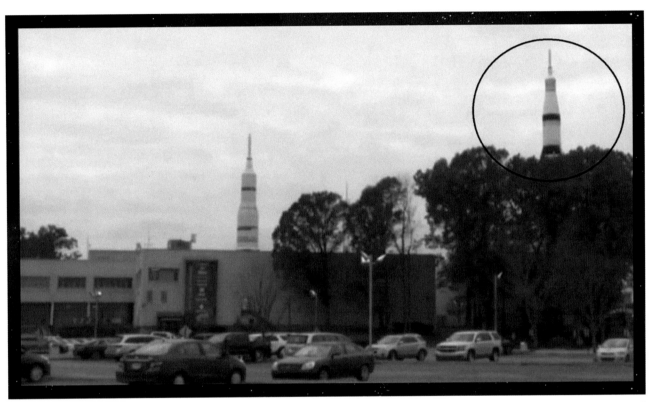

The black-and-white model has stood outside the museum since 1999, and it's showing signs of age. The center's chief executive, Deborah Barnhart, says officials plan to restore it and historic rockets at the attraction. Courtesy: WHNT (WTVY News 4) By WAFF Published: Dec. 6, 2019 at 4:12 AM CST

Do you love the U.S. Space & Rocket Center? Time magazine sure does.

The magazine named Huntsville's space center in its 2019 list of the world's coolest places for kids. They cite the center's flight simulators and Space Camp, Aviation Challenge and Robotics Camp as ways to enhance kids' interest in space. Time also notes how the USSRC is also a training ground for budding astronauts and space shuttle display.

THE PATHFINDER STATIONED AT THE U.S. SPACE & ROCKET CENTER
Source: U.S. SPACE & ROCKET CENTER / EDUCATION FOUNDATION Pathfinder -

U.S. Space & Rocket Center Education Foundation (rocketcenterfoundation.org)

The Pathfinder is a one-of-a-kind testing artifact created to develop procedures for moving and handling the space shuttle orbiters. Also known as Orbital Vehicle-098, the artifact is a steel structure roughly the size, weight and shape of an orbiter. Constructed at Marshall Space Flight Center (MSFC) in 1977, the article, later named Pathfinder, was used as a stand-in for the first orbiter, Enterprise (OV-101), to test roads and cranes.

It was shipped by barge to Kennedy Space Center to be used for ground crew testing before returning to Marshall Space Flight Center where it was stored for many years.

Image Taken by Steven Jackson Photography / Feb. 7, 2020

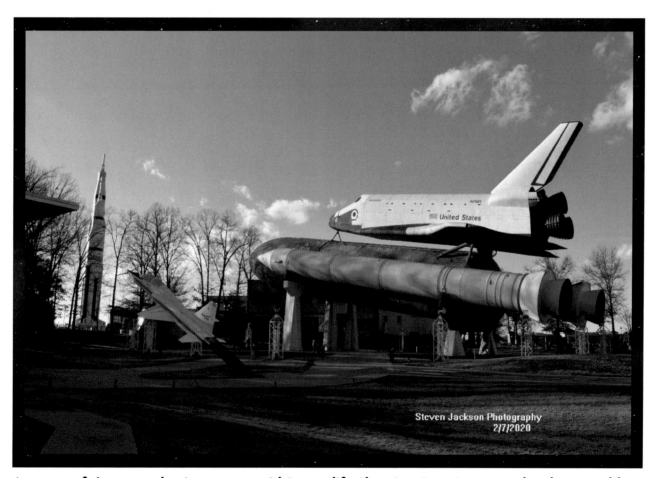

A group of Japanese businessmen paid to modify the structure to more closely resemble a real orbiter and displayed it from 1983-1984 at an exposition in Tokyo, Japan. After the expo, Pathfinder returned to Huntsville, Alabama, and has been on permanent display at the U.S. Space and Rocket Center since May 1988. It is mounted to the Main Propulsion Test Article (MPTA) External Tank, also an artifact, used for early tanking tests.

By the way, the more, I learn about the U.S. Space & Rocket Center the more, I want to learn.

HISTORY
Source: www.spacecamp.com

Space Camp is located in Huntsville, Alabama.

Huntsville is currently home to the second largest Research Park in America.

The story began when Dr. Wernher von Braun and his rocket team first came to the United States in 1945 under military contract to create ballistic rockets. They were sent to Fort Bliss, Texas to work on rocket development, but after inspecting the Redstone facilities in Huntsville which had been used during World War II for the production of pyrotechnical devices, they deemed it a better location and proposed a guided missile center.

On March 21, 1950, the von Braun rocket team moved to Huntsville and joined a group of U.S. rocketry specialists. Together, they would go on to create some of the world's first rockets and satellites to orbit the Earth. Ultimately, the Saturn V rocket that sent the American Apollo astronauts to the moon, achieving the goal of preeminence in space.

Based at the U.S. Space & Rocket Center, trainees have an unparalleled environment to spur imagination while being surrounded by space, aviation and defense artifacts.

Image Taken by Steven Jackson Photography May 21, 2019

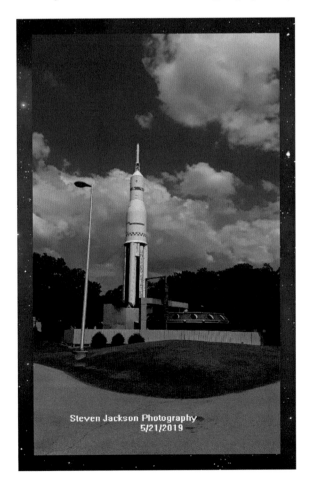

Space Camp challenges trainees to transcend from "What if?" to "Can do!" Launched in 1982, Space Camp has inspired and motivated young people from around the country, and later the world, with attendees from all 50 states, U.S. territories and more than 150 foreign countries.

Space Camp is the brainchild of rocket scientist Dr. Wernher von Braun, who led the development of the Apollo-era rockets that took America to the moon, and Mr. Edward O. Buckbee, the first director of the U.S. Space & Rocket Center.

Image Taken by Steven Jackson Photography / June 3, 2019

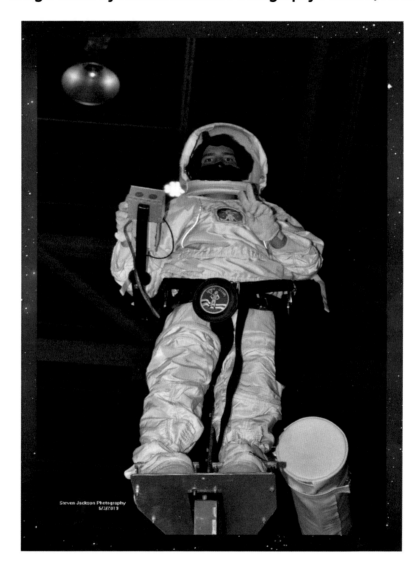

Camps are available for fourth grade through high school-age students. Special programs are offered for trainees who are blind or visually impaired, deaf or hard of hearing, and those who have other special needs. You're never too old for Space Camp!

Camp programs are also available for adults, educators, corporate groups and families. Family programs may include children as young as seven years old.

Space Camp has attracted more than 987,000 trainees since its inception.

ASTROTREK BUILDING
Image Taken by Steven Jackson Photography

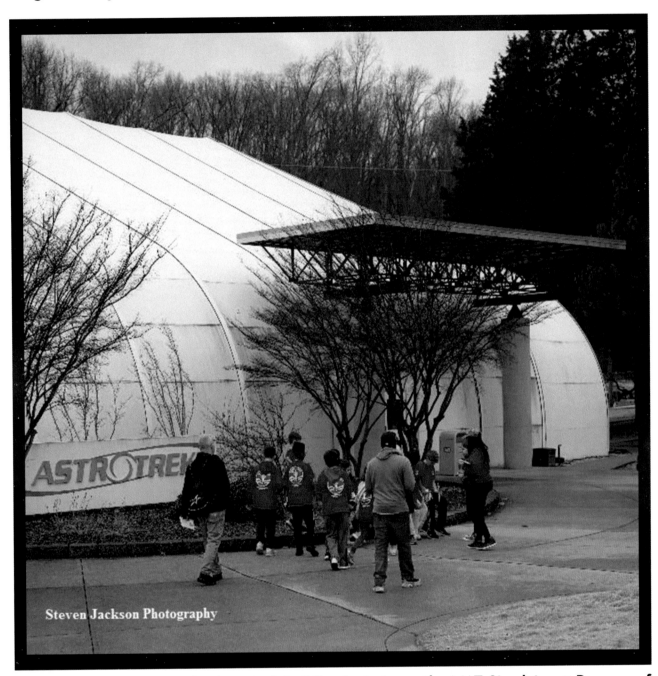

Steven Jackson Photography

Crew members entering the Astrotrek building to train on the MAT Simulator, 5 Degrees of Freedom Chair and the 1/6th Gravity Chair. As their photographer, I have the pleasure to capture all the fun they will experience in the Astrotrek building today. How cool is that!

I am their paparazzi!

MULTI-AXIS TRAINER (MAT)
Image Taken by Steven Jackson Photography

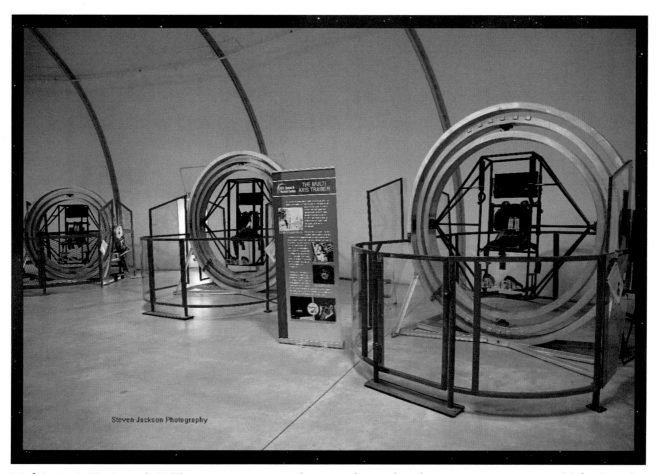

Steven Jackson Photography

Multi--Axis Trainer (MAT) is an apparatus that simulates the disorientation one would feel in the case of a tumble spin during reentry into the Earth's atmosphere. The astronauts used the MAT to condition themselves for disorientation that might occur in emergency conditions in outer space. This is a simulator you don't want to pass-by.

MULTI-AXIS TRAINER (MAT)
Image Taken by Steven Jackson Photography

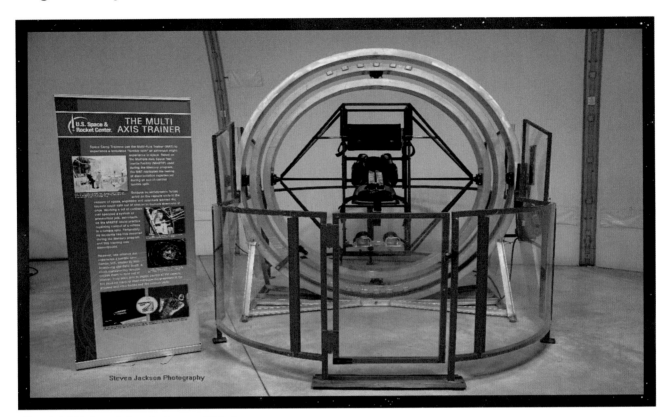

This MAT simulator is incredible!

Image Taken by Steven Jackson Photography

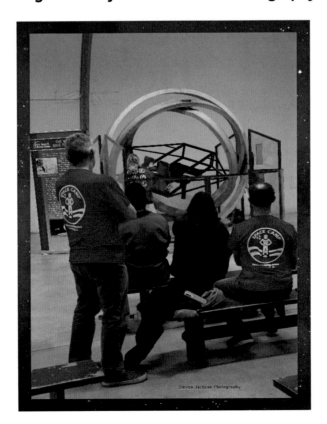

MULTI-AXIS TRAINER (MAT)
Image Taken by Steven Jackson Photography

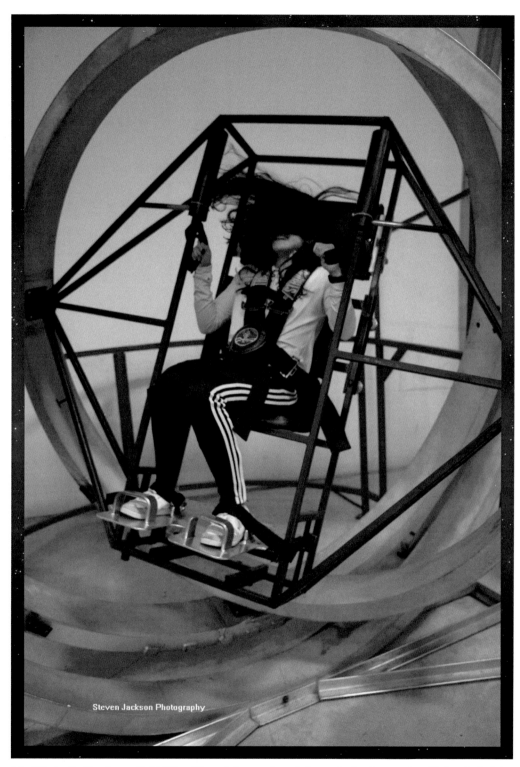

Multi-Axis Trainer (MAT) – Simulates a tumble spin but you don't feel sick!

What you do feel is Fun! Fun! Fun! And more Fun! How cool is that!

MULTI-AXIS TRAINER (MAT)
Image Taken by Steven Jackson Photography

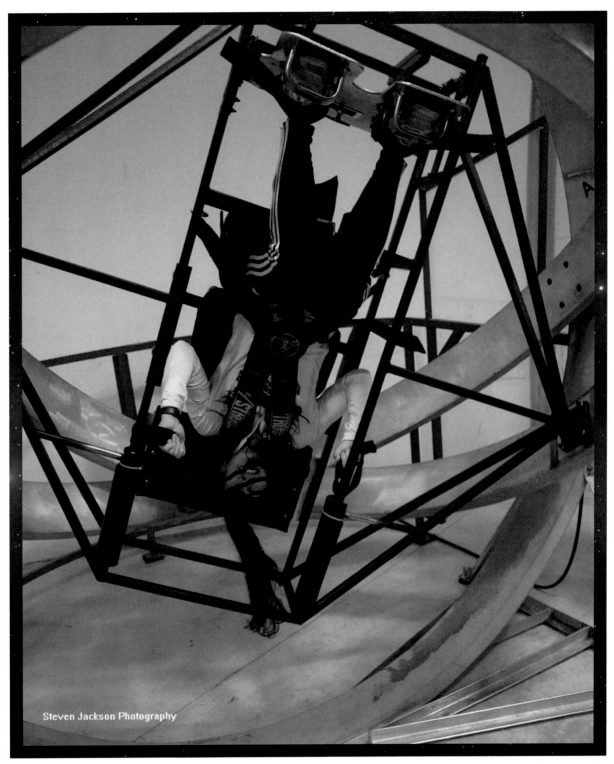

Steven Jackson Photography

(MAT) – You'll move all around and turn upside down; how cool is that! You can't fall out the MAT, you're strapped-in like a baby in a car seat.

MULTI-AXIS TRAINER (MAT)
Image Taken by Steven Jackson Photography

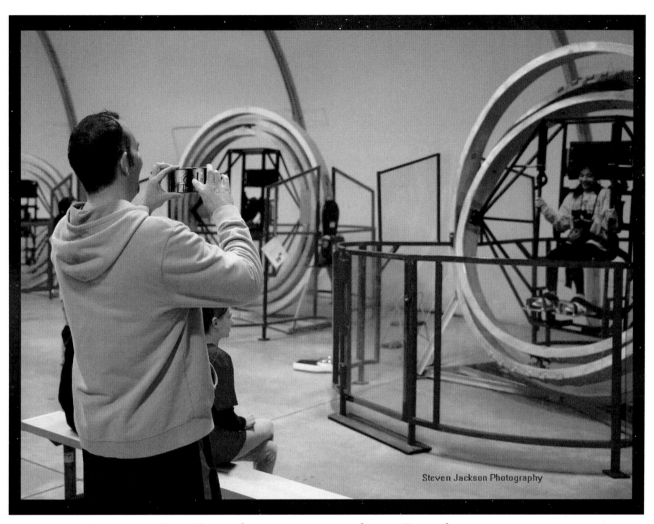

MULTI-AXIS TRAINER (MAT) – A photo moment on the MAT simulator

DAY 3

5 DEGREES OF FREEDOM CHAIR (5DF)
Image Taken by Steven Jackson Photography

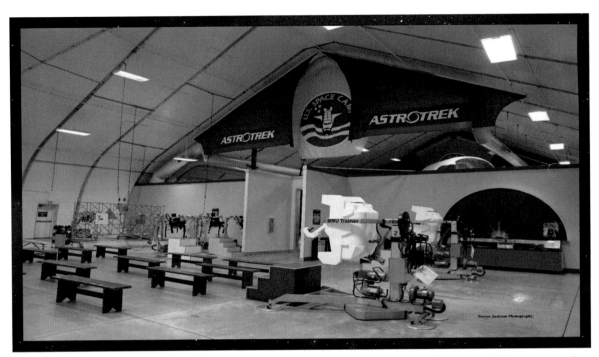

5DF stands for "five degrees of freedom". In space there are six degrees of freedom of movement: up/down, left/right, back/forth, pitch (leaning forward or backward), roll (tilting to the side), and yaw (turning sideways around a vertical axis). This chair simulates all three spins by being on hinges and is free to move in any direction horizontally, since it is on hover pads. This simulator can not go up or down.

Image Taken by Steven Jackson Photography

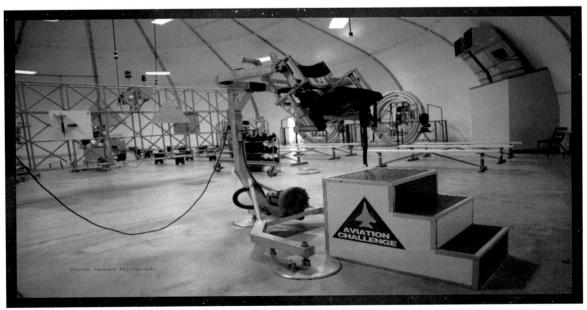

5DF Chair glides across the floor on hover pads that releases air pressure on the floor.

5 DEGREES OF FREEDOM CHAIR (5DF)
Image Taken by Steven Jackson Photography

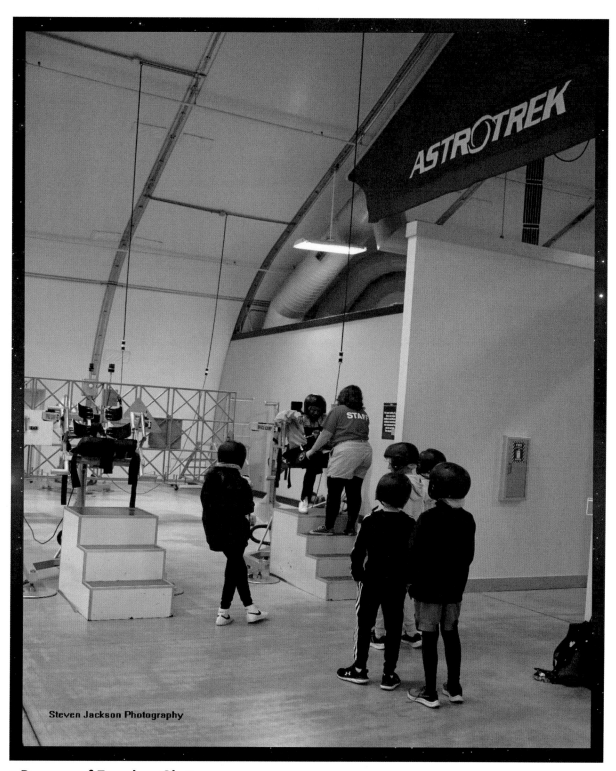

5 Degrees of Freedom Chair

5 DEGREES OF FREEDOM CHAIR (5DF)
Image Taken by Steven Jackson Photography

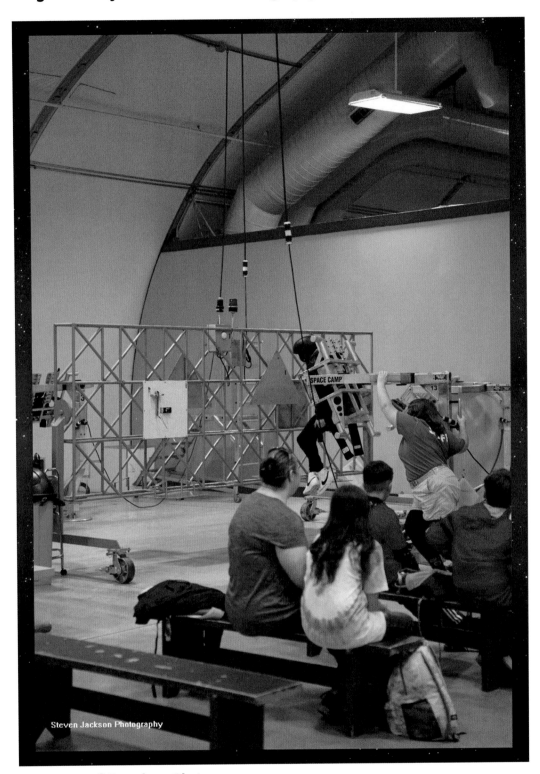

5 Degrees of Freedom Chair

5 DEGREES OF FREEDOM CHAIR (5DF)
Image Taken by Steven Jackson Photography

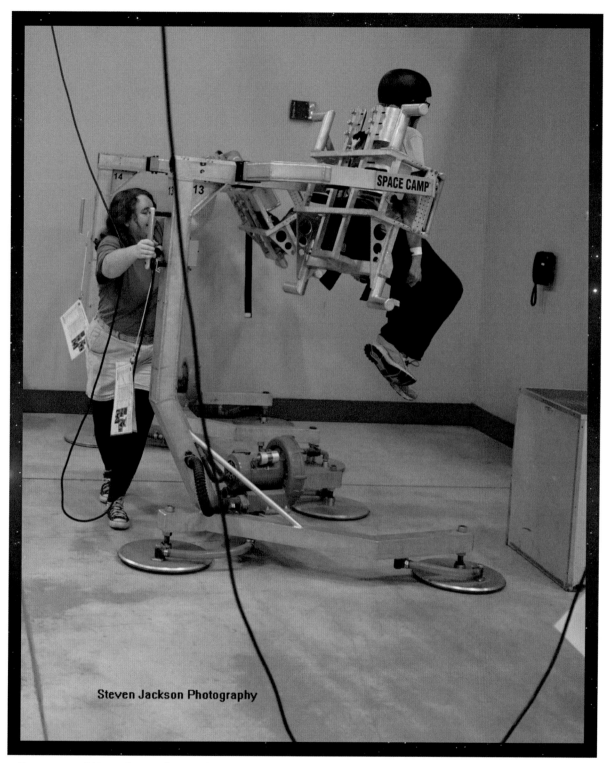

Steven Jackson Photography

5 Degrees of Freedom Chair vibrates as the air pressure underneath the round hover pads forces the heavy-duty simulator to glide across the floor with the help of the crew trainer. Mind you, the person seated in the 5DF Chair is strapped-in like a baby in a car seat.

DAY 4

1/6th GRAVITY CHAIR
Image Taken by Steven Jackson Photography

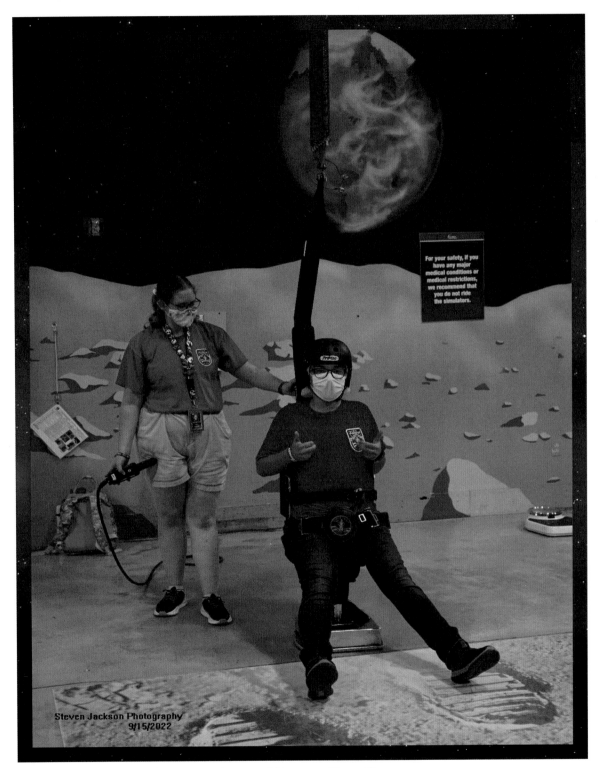

Steven Jackson Photography
9/15/2022

1/6th Gravity Chair shows us what it's like to walk on the moon.

1/6th GRAVITY CHAIR
Image Taken by Steven Jackson Photography

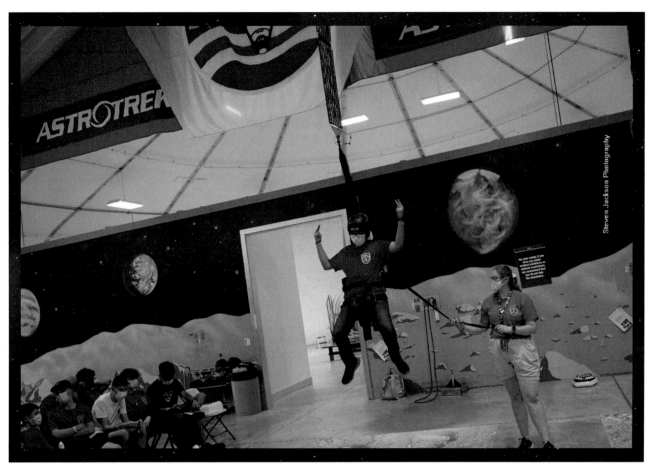

1/6th Gravity Chair is attached to the ceiling with very large springs and slides along an iron track that extends across the ceiling wall. When you try to use your legs, the springs will cause you to bounce, bounce, bounce across the floor like walking on the moon.

1/6th GRAVITY CHAIR
Image Taken by Steven Jackson Photography

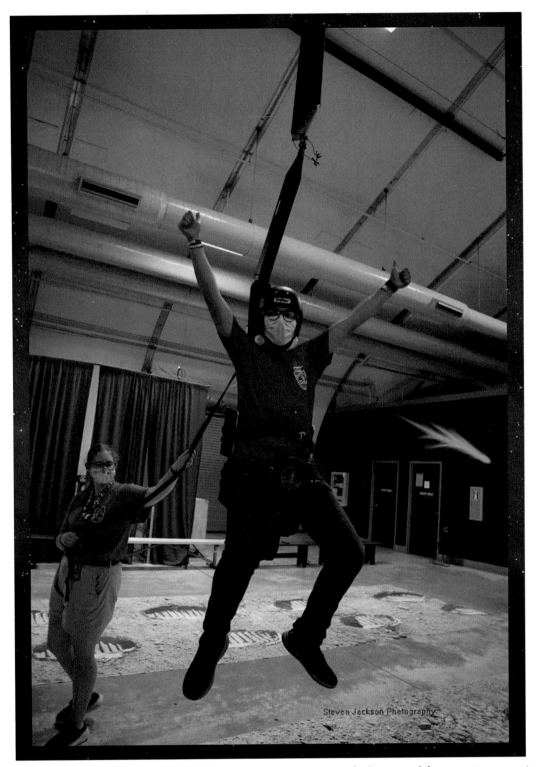

Steven Jackson Photography

1/6th Gravity Chair simulator gives you an out of this world experience. As a photographer capturing moments like this makes my job worth a million bucks!

CONTROL ROOM / UPDATE
Image Taken by Steven Jackson Photography

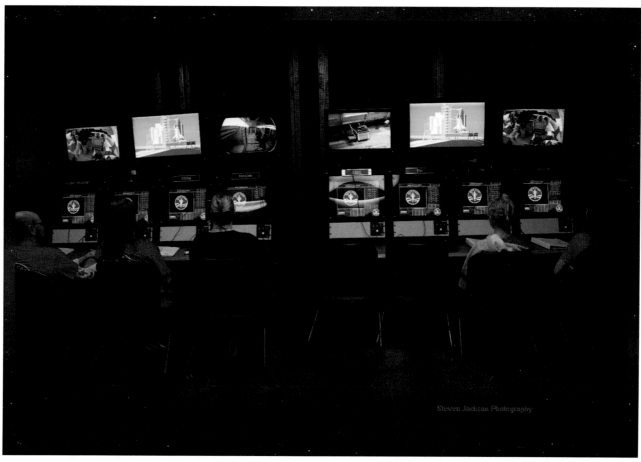

Control Room - It can take from 6 hours to 3 days to reach the International Space Station

FLIGHT DECK / UPDATE
Image Taken by Steven Jackson Photography

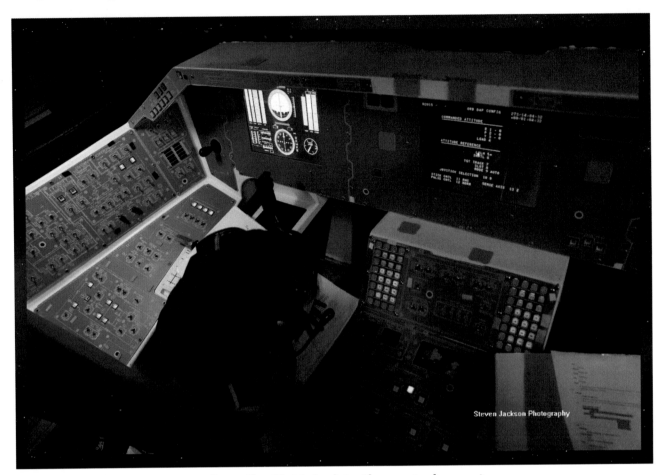

Fight Deck – Communication from the flight deck to the control room in progress.

PATHFINDER SHUTTLE
Image Taken by Steven Jackson Photography

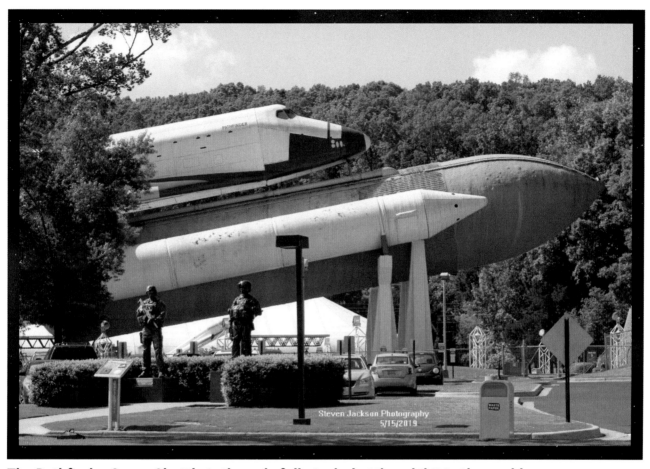

The Pathfinder Space Shuttle is the only full-stack shuttle exhibit in the world.

UNDERWATER ASTRONAUT TRAINING (UAT)
Image Taken by Steven Jackson Photography / Aug. 25, 2020

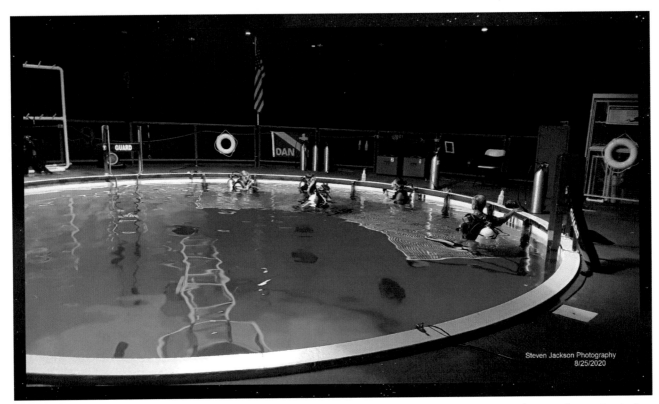

UAT swimming pool was built to teach Space Camp and Space Academy students the principles of being able to function in a weightless condition environment.

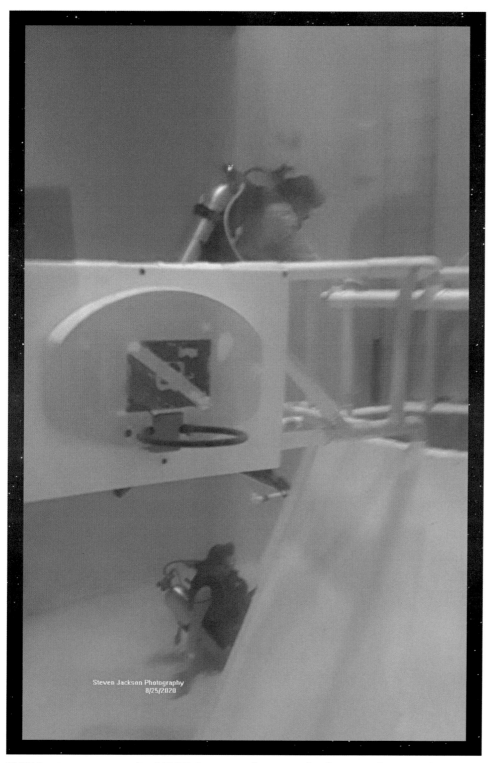

UAT instructors at the USSRC are scuba certified in teaching under water activities. The trainees get to have fun while learning what it's like to live and work in space. How cool is that!

THE MCC FLOOR / UPDATE
Image Taken by Steven Jackson Photography

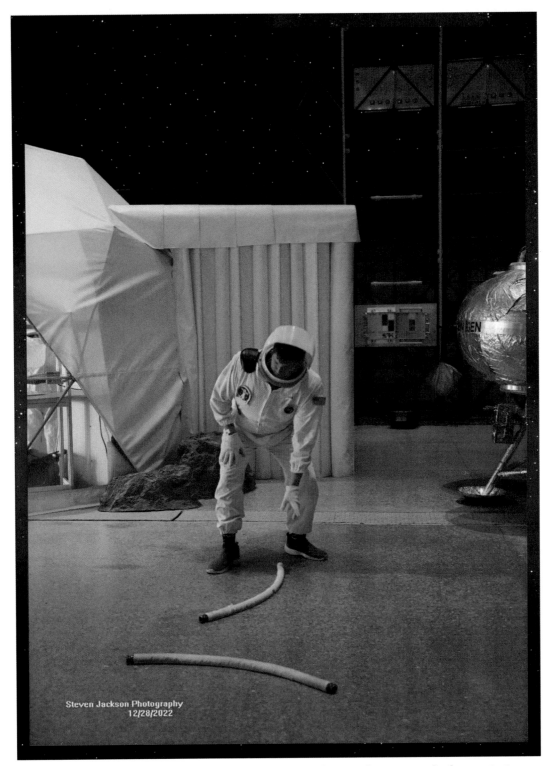

Steven Jackson Photography
12/28/2022

Communication received on the MCC Floor that a chaotic turbulence is in progress during the space mission, a life threating event.

THE MCC FLOOR / UPDATE
Image Taken by Steven Jackson Photography

Steven Jackson Photography
12/28/2022

Possible injuries from an unknown occurrence during a space mission.

THE MCC FLOOR / UPDATE
Image Taken by Steven Jackson Photography

So far, no astronaut has ever been lost in space during a space mission EVA. Astronauts train very hard to avoid any possible life-threatening encounters while in outer space.

THE MCC FLOOR / UPDATE
Image Taken by Steven Jackson Photography

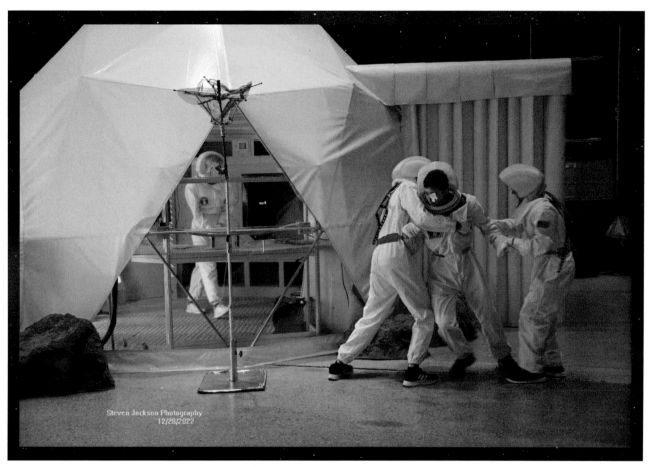

The key threats to human health performance associated with spaceflight are radiation, altered gravity fields, distance from Earth, and isolation and confinement.

DAY 5

AVIATION CHALLENGE
Image Taken by Steven Jackson Photography / June 27, 2019

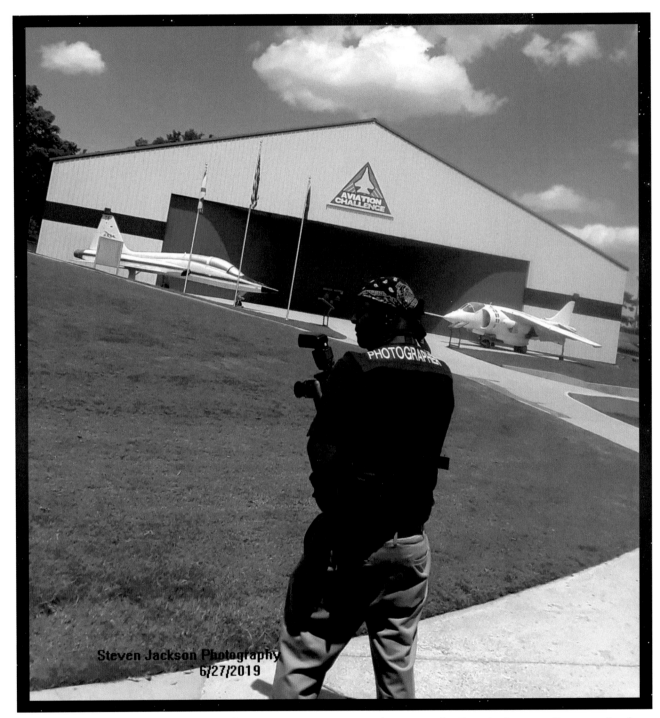

Aviation Challenge is one of my favorite programs to photograph. Reminds me of my early days in boot camp. The trainees arrive here as individuals but grow to learn how to trust others as teammates, learn leadership skills and experience aviation themed activities.

AVIATION CHALLENGE
Image Taken by Steven Jackson Photography / May 23, 2019

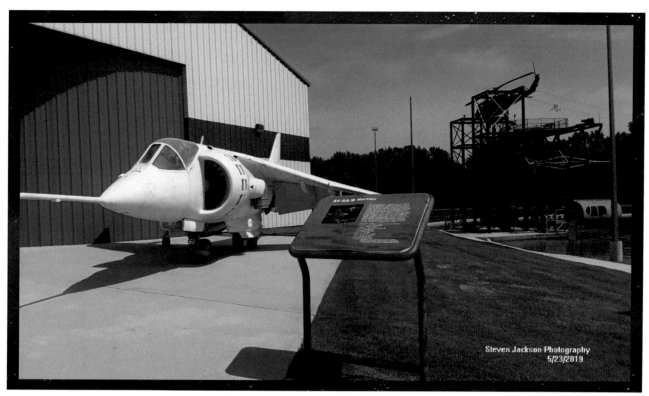

The AV-8A Harrier is primarily used on light attack and air support of ground troops. Trainees are taught in a classroom setting the history of the Harrier and other aircrafts.

AVIATION CHALLENGE
Image Taken by Steven Jackson Photography

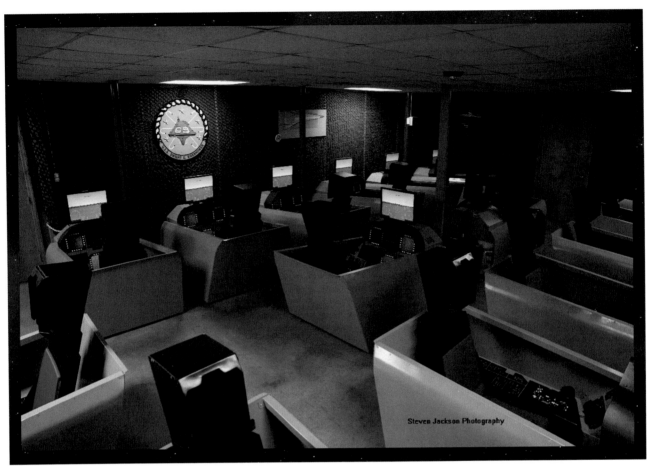

Steven Jackson Photography

In this classroom setting trainees get to learn maneuvers of flight in flight simulators. The challenge is real, and the fun is incorporated into the challenge. Let's go get it!

AVIATION CHALLENGE
Image Taken by Steven Jackson Photography

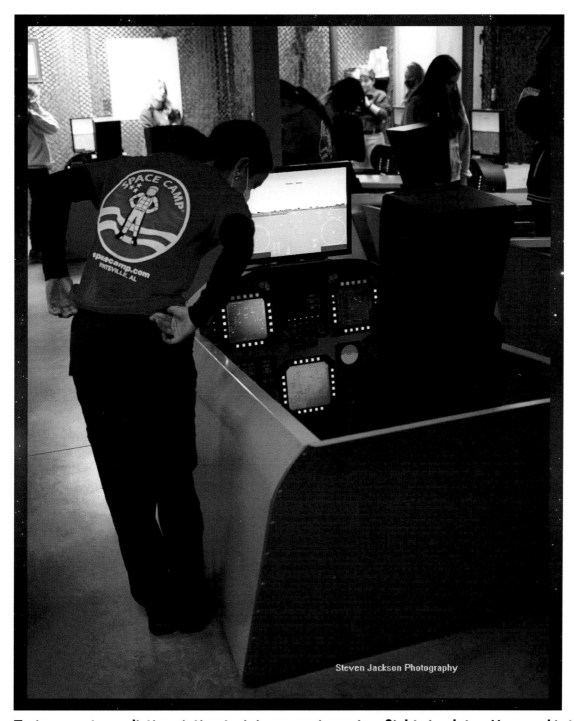

Steven Jackson Photography

Trainees get a realistic aviation training experience in a flight simulator. How cool is that!

AVIATION CHALLENGE
Image Taken by Steven Jackson Photography

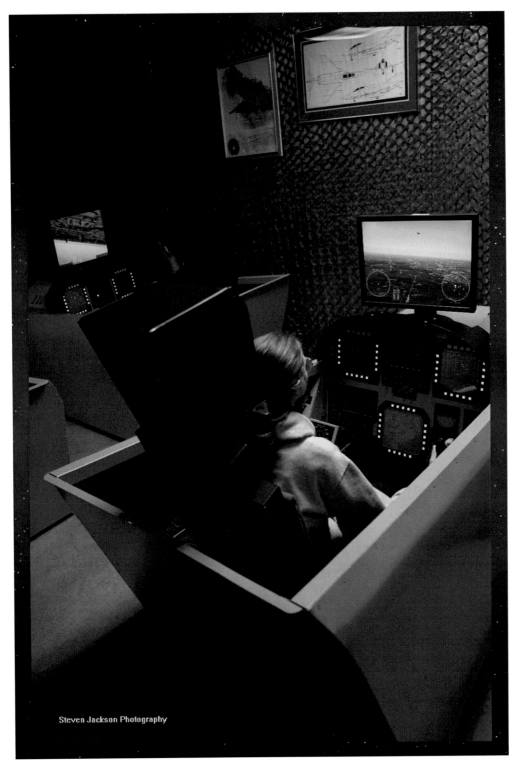

Steven Jackson Photography

Trainees are totally focused on their in-flight training in the assigned simulator.

AVIATION CHALLENGE
Image Taken by Steven Jackson Photography

Steven Jackson Photography

Crew instructors are trained to give excellent guidance on flight maneuvers. Trainees get to learn pilot and survival skills individually and as a team.

AVIATION CHALLENGE
Image Taken by Steven Jackson Photography

Steven Jackson Photography

AVIATION CHALLENGE
Image Taken by Steven Jackson Photography / May 27, 2019

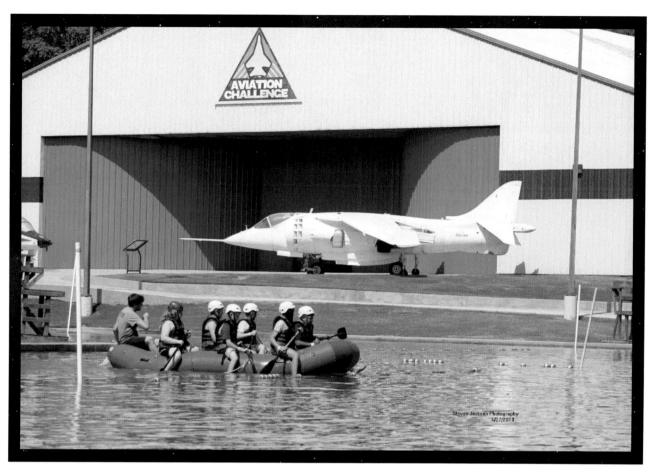

Trainees get to practice their teamwork and survival skills on land and at sea! As a staff photographer, I get the pleasure to capture great moments at the right time. When you join in on the fun at the U.S. Space & Rocket Center, I'm the right photographer for you!

AVIATION CHALLENGE
Image Taken by Steven Jackson Photography / May 23, 2019

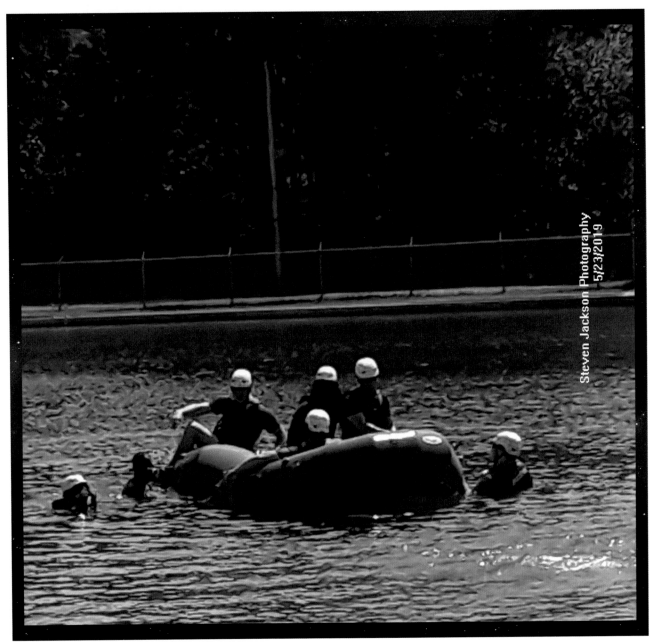

Kids can't help but have a lot of fun while they train during their water tactics at aviation challenge. Moments like this will always be remembered; my photos will make sure of it.

DAY 6

ROCKET LAUNCH
Image Taken by Steven Jackson Photography July 26, 2019

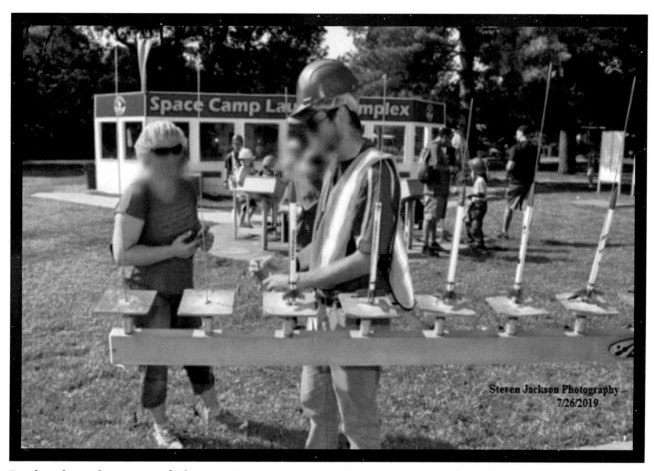

Rocket launch is one of the most exciting activities on campus. In a classroom setting, crew trainees get to build a standard space camp rocket and launch the rocket the same day.

ROCKET LAUNCH
Image Taken by Steven Jackson Photography / July 26, 2019

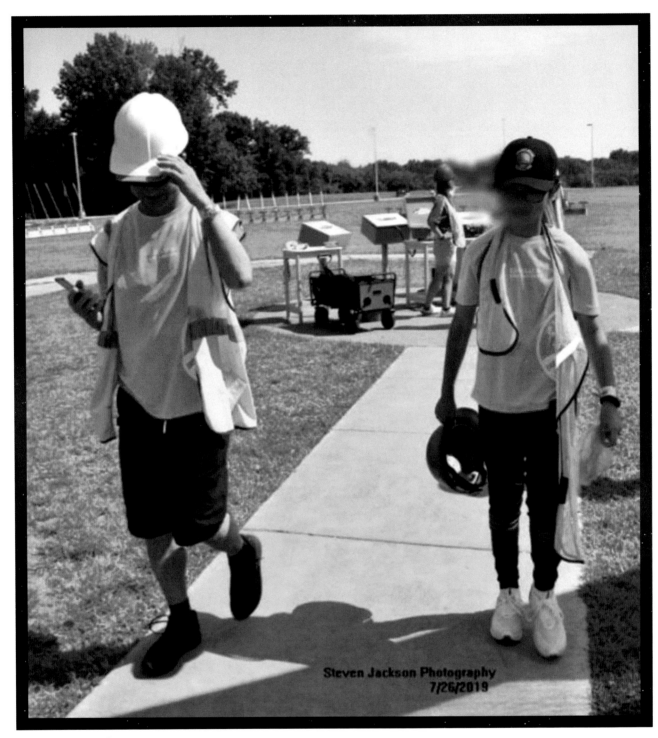

Steven Jackson Photography
7/26/2019

Rocket Launch in progress

ROCKET LAUNCH
Image Taken by Steven Jackson Photography / July 26, 2019

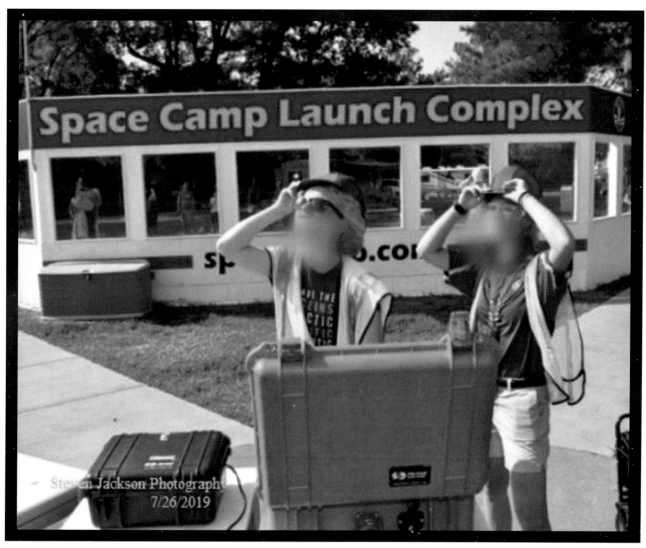

Trainees get to watch their self-made rocket blast off into the clouds then descend back to Earth. The parachute pops out of the body of the rocket and glides down to the ground.

ROCKET LAUNCH
Image Taken by Steven Jackson Photography / July 26, 2019

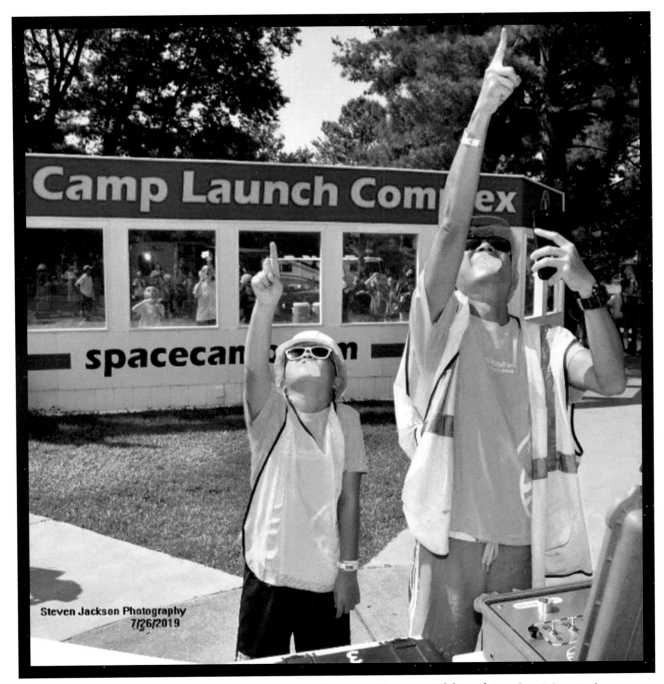

Along with the thrill of you launching your rocket into the great blue skies, I get to capture your experience on many photographs that you will cherish forever! How cool is that!

NEXT

THE ZIP LINE / ELITE TEAMS
Image Taken by Steven Jackson Photography

Steven Jackson Photography

The Zip Line is an action-filled, high wire adventure. Zip Lines are heavy duty cables connected between two points that slop downward from a high elevation to a low elevation.

ZIP LINE / ELITE TEAMS
Image Taken by Steven Jackson Photography

Steven Jackson Photography

PREPARATION AREA – The Elite members are fitted into a body harness for safety. I'm fortunate to be here to capture their journey every step of the way. Now, how cool is that!

THE ZIP LINE / ELITE TEAMS
Image Taken by Steven Jackson Photography

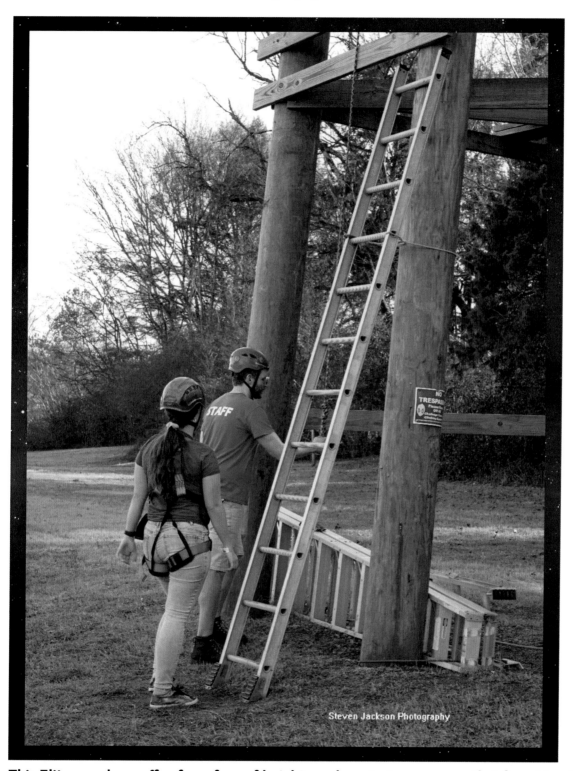

Steven Jackson Photography

This Elite member suffer from fear of heights and wants to overcome that fear. How to do that? Well, by challenging herself on this high-speed Zip Line.

THE ZIP LINE / ELITE TEAMS
Image Taken by Steven Jackson Photography

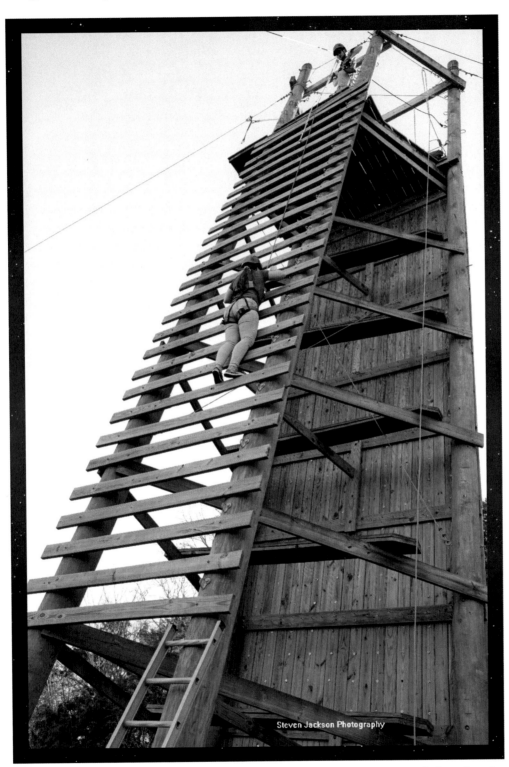

Steven Jackson Photography

The Elite Team members wants to get their hands dirty and reach for the skies. I say it all the time... the challenge is real, the fun is incorporated into the challenge. How true is that!

THE ZIP LINE / ELITE TEAMS
Image Taken by Steven Jackson Photography

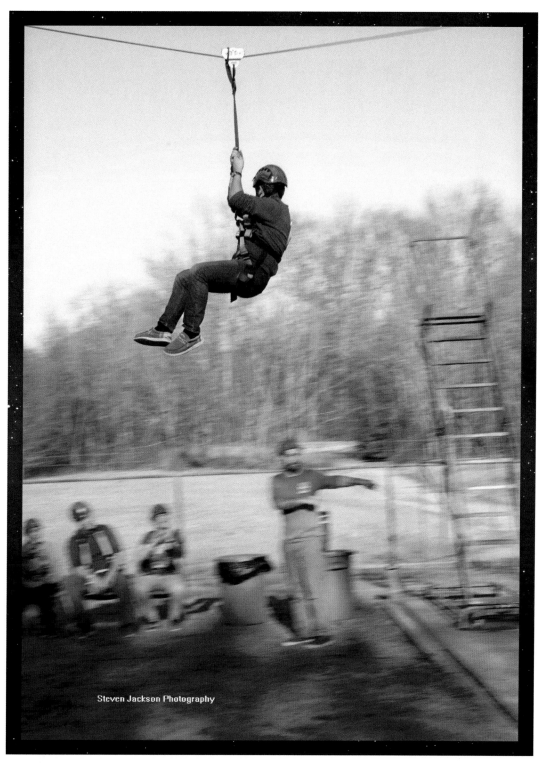

Steven Jackson Photography

The fitted body harness clips onto the heavy-duty cables via a pulley. These pulleys are designed to reduce friction, allowing the Elite member to accelerate down the Zip Line at high speed. This is an excellent way to challenge yourself when you're fearful of heights.

DAY 7

DAVIDSON CENTER
Image Taken by Steven Jackson Photography

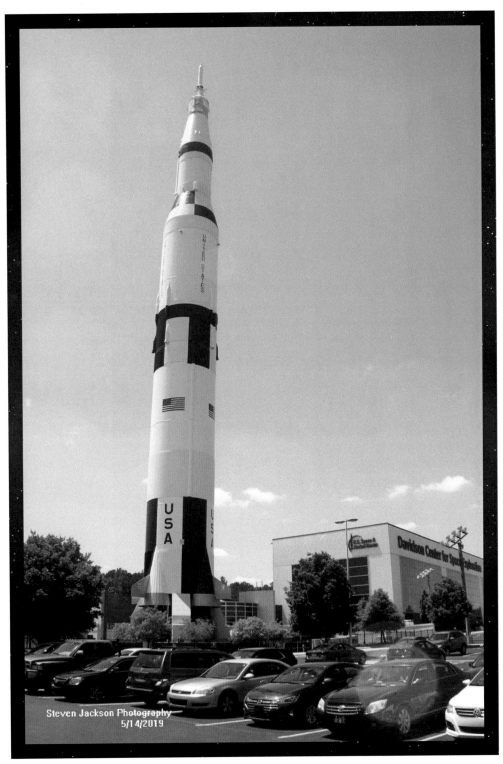

U.S. SPACE & ROCKET CENTER / DAVIDSON CENTER

DAVIDSON CENTER
Image Taken by Steven Jackson Photography

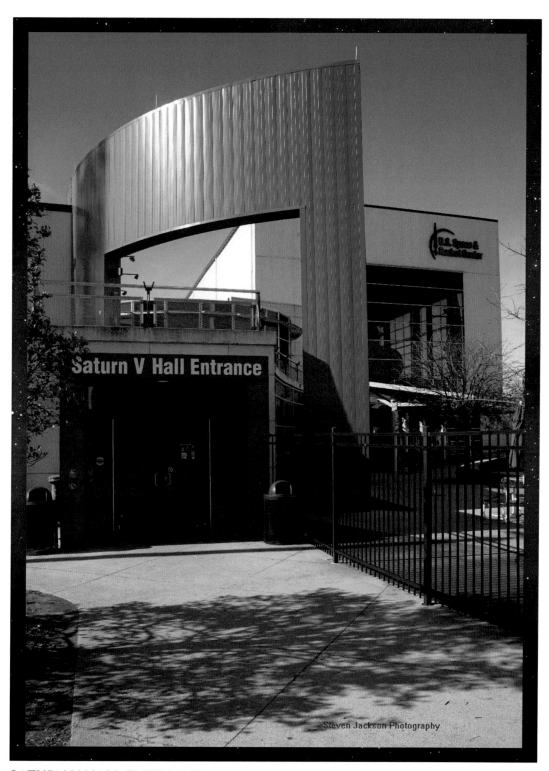

SATURN V HALL ENTRANCE

DAVIDSON CENTER

Image Taken by Steven Jackson Photography

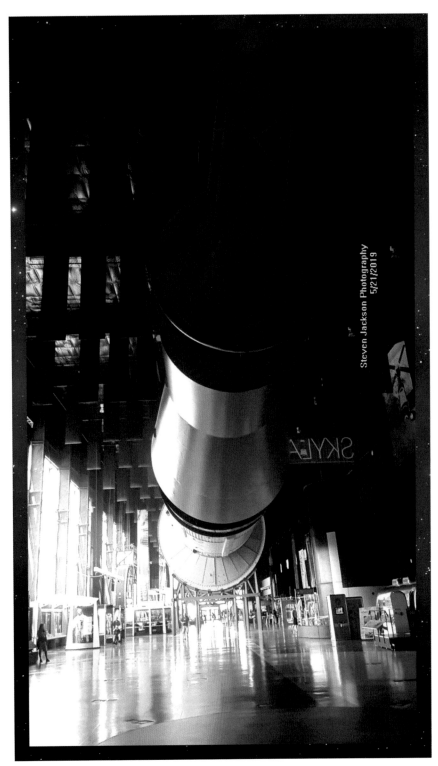

SATURN V HALL

DAVIDSON CENTER
Image Taken by Steven Jackson Photography

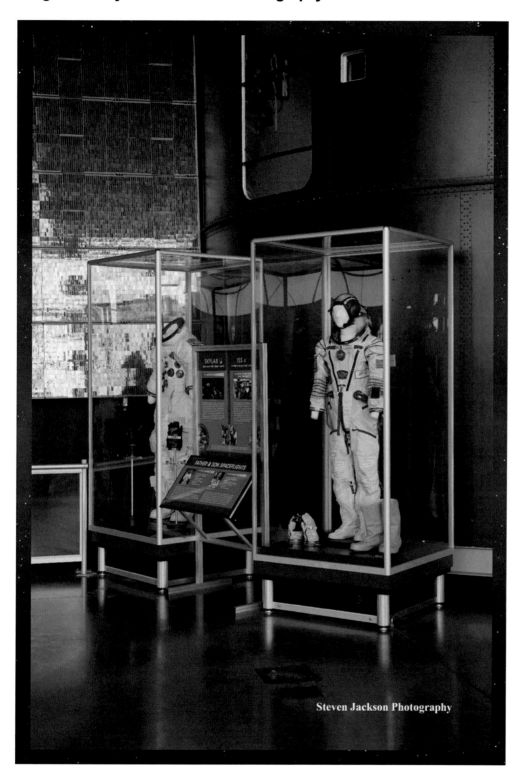

Steven Jackson Photography

DAVIDSON CENTER

APOLLO 16 COMMAND MODULE
Image Taken by Steven Jackson Photography / May 21, 2019

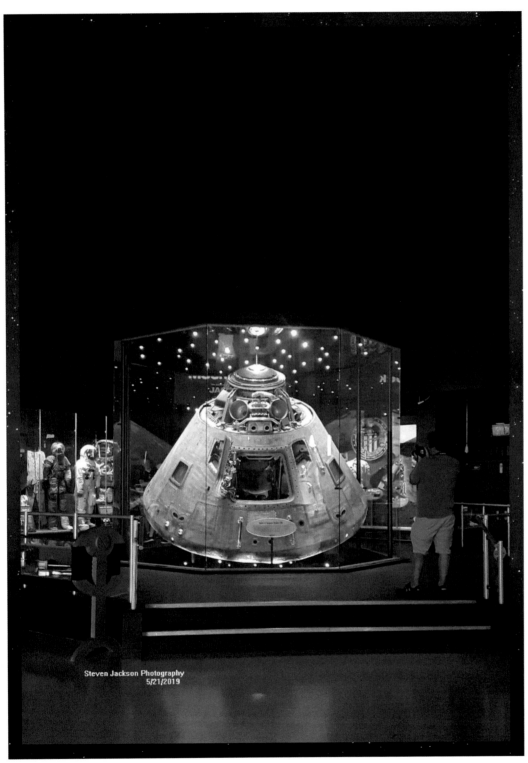

April 16, 1972, The Apollo 16 Command Module traveled from Earth to the moon and returned back to Earth April 27, 1972; a space mission well done.

DAVIDSON CENTER

SPACE CAMP GRADUATION
Image Taken by Steven Jackson Photography / May 22, 2019

Steven Jackson Photography
5/22/2019

U.S. Space & Rocket Center / Space Camp Graduation about to begin.

DAVIDSON CENTER

SPACE CAMP GRADUATION
Image Taken by Steven Jackson Photography / May 22, 2019

U.S. Space & Rocket Center / Space Camp Graduation about to begin.

DAVIDSON CENTER

SPACE CAMP GRADUATION
Image Taken by Steven Jackson Photography / May 22, 2019

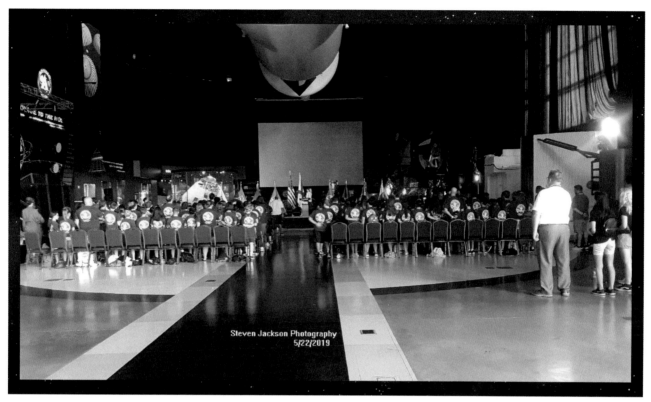

U.S. Space & Rocket Center / Space Camp Graduation in progress.

DAVIDSON CENTER

SPACE CAMP GRADUATION
Image Taken by Steven Jackson Photography / May 22, 2019

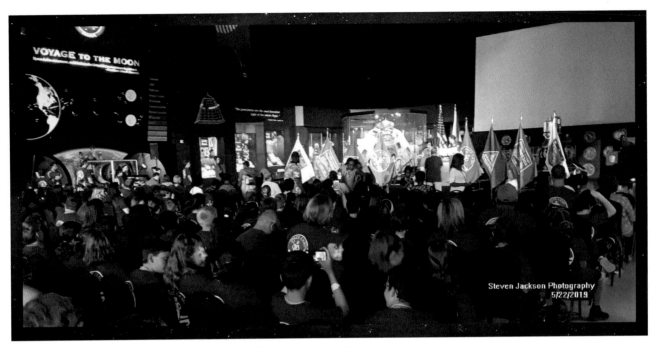

U.S. Space & Rocket Center / Space Camp Graduation

DAVIDSON CENTER

ASTRONAUT ROBERT C. SPRINGER
Image Taken by Steven Jackson Photography / May 22, 2019

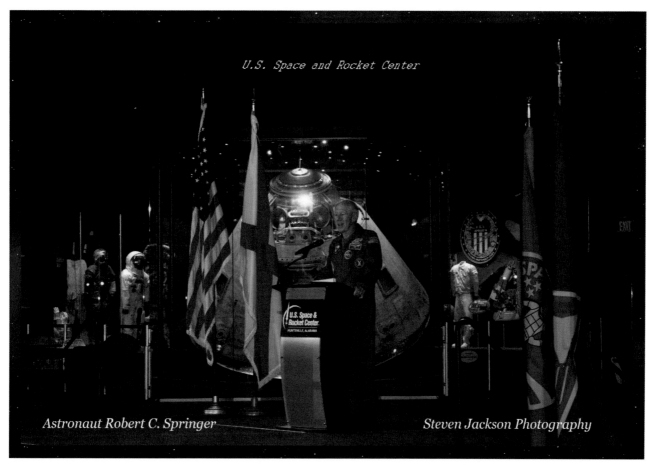

U.S. Space & Rocket Center / Space Camp: Astronaut Robert C. Springer is the guest speaker.

DAVIDESON CENTER
Image Taken by Courtney Photography / June 7, 2019

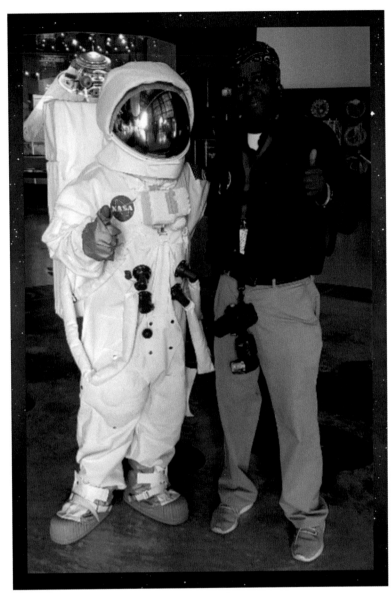

Space Camp Astronaut and Steven Jackson Staff Photographer

Throughout my whole career as a photographer, working as a Staff Photographer here at the U.S. Space & Rocket Center is my best experience ever as a photographer. Also, history will show that, I am part of the first generation of Staff Photographers hired at the U.S. Space & Rocket Center. How cool is that!

In honor of the first generation of Staff Photographers here at the USSRC, they are:

Kerry Brooks, Chris Wade, Courtney, Jim, Robert, Bobby, Jackson, Alexa, Kenneth, Gabby, Mari, Bailey, Brooks, Avery, Trina, Savannah, Christian, Micah and Kiahana.

Printed in the United States
by Baker & Taylor Publisher Services